MW00327313

# IMAGES
## *of America*

# IRISH SAVANNAH

Sheila Counihan Winders

ARCADIA
PUBLISHING

Copyright © 2014 by Sheila Counihan Winders
ISBN 978-1-4671-1193-5

Published by Arcadia Publishing
Charleston, South Carolina

Printed in the United States of America

Library of Congress Control Number: 2013953619

For all general information, please contact Arcadia Publishing:
Telephone 843-853-2070
Fax 843-853-0044
E-mail sales@arcadiapublishing.com
For customer service and orders:
Toll-Free 1-888-313-2665

Visit us on the Internet at www.arcadiapublishing.com

*Dedicated with great love to my parents, grandparents, and my whole big Irish family, who made sure I was "raised on songs and stories and heroes of renown" and loved from day one. Also, love and thanks to my husband, who thought I'd never finish this book but who believes in and encourages me in all my endeavors. When it comes to the people in my life, I have found that Irish pot of gold at the end of the rainbow!*

IMAGES
*of America*

# IRISH SAVANNAH

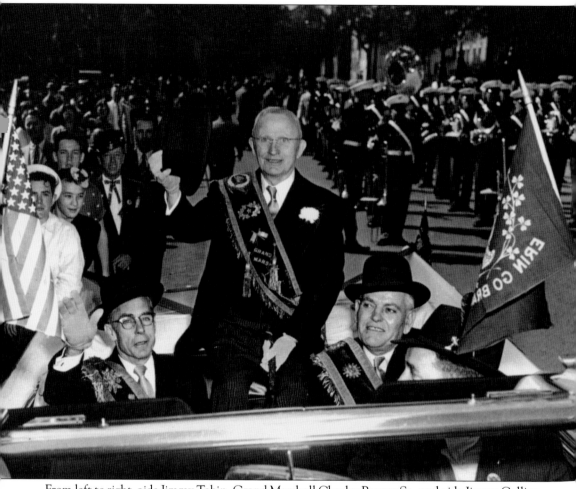

From left to right, aide Jimmy Tobin, Grand Marshall Charles Powers Sr., and aide Jimmy Collins wave to the crowds during a lull in the St. Patrick's Day Parade. (Courtesy Powers family.)

ON THE COVER: From left to right, Bob Downing, Bart Shea, Dick Fogarty, Jimmy Glass, Jimmy Glass Jr., Joe McDonough, and Tom Canty stand in front of the cathedral after St. Patrick's Day Mass in 1949. If they aren't in front of the cathedral, many of the men are probably down the street at Pinky Masters, which has supplied a "bit of Irish" to parade-goers and participants for years. (Courtesy Anne Marie Collins.)

# CONTENTS

# ACKNOWLEDGMENTS

To all the wonderful people who brought me pictures and stories, you have my heartfelt thanks. Thanks especially to JoAnn Aulwes, who brought me my first picture immediately after I announced I was writing this book. Many thanks also go to Jack Jaugstetter, Genevieve Pinckney, Antoinette Ryan, Julie Blair, Georgia Spellman, Mary Forbes, St. Vincent's Academy, Kitty Hernandez, Anne Marie Collins, Cecilia Courtenay, Sr. Susan Harms, Elizabeth Ware, Marie Green, Ted Haviland, Joe Counihan, Jerry Counihan, Deborah Carroll, Mutt Sheppard, Paul Camp, and Pete DeBorde, as well as the Sullivan family and Nancy Cunningham for material.

My most heartfelt thanks go to Gill Brown, the wonderful director of the Diocese of Savannah Archives. Gill has been more than patient, more than kind, and a wonderful source of information. I owe you and *really* am going to become a volunteer!

Liz Gurley of Arcadia Publishing has gained many shamrocks in her crown for the patience she has shown to someone who has never done anything like this before. She truly proves that patience is a virtue and is a delight to work with. Patient though she may be, I don't think this is the time to tell her I have another idea for a great book!

# INTRODUCTION

*Cead Mile failte!* A hundred thousand welcomes to you, the reader of this book. The Irish are known for their tales and I have one for you. Long ago, when our sons were two and four, my husband and I had Santa visit our home one night before Christmas. We had the boys in their footie pajamas and the Christmas tree lit. When the doorbell rang, we asked our older son to answer it. He opened the door and, as a true little Irishman who is never without words, said, "Santa! Come in! This is my mother, my father, and my little brother. Would you like a drink?"

In that spirit, I ask you to sit down and have a drink (sweet iced tea or Coke, as I am from Georgia) or something stronger, and enjoy getting to know us, the Savannah Irish.

Many Savannahians subtly alter the saying "American by birth; Southern by the grace of God" to "American by birth; Savannahian by the grace of God." In the case of the Irish who came to Savannah with hopes for their future based on letters from friends, articles in the newspapers, rumors of jobs, and (perhaps) the already Southern thought that there was more to America than those Yankees and that miserable Northern cold, their saying would be "Irish by birth; Savannahian by choice."

It was indeed a choice that these men and women made when undergoing a second migration from the ports of Boston or New York, where they landed, to travel south to a land of hot, humid weather, so unkind to Irish skin, and full of bugs and insects. It was also another expense, so they had worked for a while in Boston or New York to earn the money. But, for various reasons, they did come, and they stayed and prospered. Even after the yellow fever epidemic of 1854, in which about 40 percent of all deaths were Irish, mainly because of their poor living conditions, the Irish came because opportunity overcame obstacle.

Savannah has the second largest St. Patrick's Day parade in the United States after New York (Chicago and Boston argue this point, but Savannah's is without doubt the one with the best weather). Yet when people think of the Irish in America, they always think of the northern states. It is true that very few immigrants came directly to Savannah, even though Savannah has always had a busy waterfront. There were regularly scheduled ships from England and Ireland to New York and Boston, and the majority of the Irish emigrants came to the United States that way. In the 19th century, however, a regular steamship route that was reasonably priced allowed this second migration to be somewhat easier.

Most Irish emigrants in the 19th century were from the south of Ireland and were poor and uneducated. Some had the advantage of speaking English (albeit with a brogue), but others spoke only Gaelic. Their reasons for coming were mainly economic, which the Great Famine increased. However, the first waves of emigrants in the 18th century were of a different breed. They were mainly Protestants from the north, predominately Ulster (Scotch Irish). They came with money, education, and purpose and succeeded in establishing themselves in the city. Although the Scotch Irish disagreed with their countrymen over religion, they formed the Hibernian Society to offer aid to fellow Irishmen in need. This society remains in existence today and enjoys a great

camaraderie with the St. Andrews Society, many of whose members have ancestors who were founding members of the Hibernians.

One trait of the Irish is love of family, of home, and of country. Although they may fight among themselves (the definition of Irish Alzheimer's is you forget everything except a grudge), God help anyone else who does. This great trait is what helped the Irish on arrival in the United States and what helped them succeed. It is also what has kept the Irish community cohesive through the years. Irishmen who came to Savannah wrote home to family and friends, giving them information. They also shared this information with fellow Irish who were still in the large northern cities. Savannah became known as a city that was religiously tolerant with work available and that already had an Irish connection.

Through the years that followed the influx of Irish into Savannah, many families who chose to come also chose to remain. Many things have changed, including the professions, education, and living conditions of the Irish. However, what has not changed is the tie to Ireland, the love of family and clan, and the fun loving spirit.

The 2005 grand marshal of Savannah's St. Patrick's Day Parade (the greatest honor a Savannah Irishman can receive), Dan J. Sheehan, coined a word that illustrates the spirit of the Savannah Irish: "jollification," the art of making events happy. For the Irish, there is always a joke at a wake and a tear at a wedding.

In the following pages, you will get a taste of what it is to be Irish in Savannah. If you like it and wish you were part of us, remember, there is always room for a Savannah Irishman by choice!

# One

# THE EARLY IRISH

Early Savannah Irish were a prideful bunch, maintaining their heritage in many ways. Some families can show a succession of pictures of their ancestors from arrival in Savannah to the present; others have only the occasional image and a passed-down oral description. For example, there is only one small snapshot of Joseph Ward, a skilled ships carpenter, but his family's stories of how he always "saucered" his coffee to drink it and called his young grandson "the Judge" make him seem alive even though he has been deceased for over 70 years.

Most of these families are potato famine immigrants, their ancestors having left Ireland after the Great Famine (1845–1848). The stifling English rule and the failure of the potato crop led them to leave their beloved Ireland to seek a better life. Early Irish settlers in Savannah, however, were mostly Protestant and well off. They came to establish businesses. Not many pictures exist of early Irish settlers; however, in the early photographs available, one can see who was wealthy and who was not just by the clothes. If the clothes look borrowed just for the picture, they probably were. There are stories told about wakes (always held at home in the early days) when everyone in the neighborhood would donate furnishings so that the home of the deceased would look good for the wake. Immediately after the corpse was taken out of the home, so were the borrowed goods.

As the Irish came to Savannah, the question "What was your mother?" became commonplace. That question doesn't mean to inquire about a mother's job; it's asked to discover what her maiden name was. The Irish in Savannah didn't always marry Irish, so some Irish looking people had distinctively non-Irish surnames. This question cleared the air and gave insight into the person's background. However, when parents asked this of a young woman's date, they would then begin to make connections between families so that the beginning of what was supposed to be a romantic evening became a lesson in genealogy, Irish style.

In the following pages, there will be many more family names, but even that won't be the entire list. In fact, one of the Powers family's sons-in-law actually made a card that said, "If you are married to a Powers, that means you are also related to . . ." He then listed over 50 Irish names! So, in the spirit of "What was your mother?," remember to ask that question before making a disparaging comment about a Savannahian. Chances are, they are related!

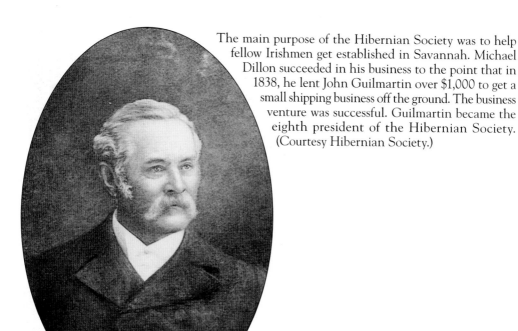

The main purpose of the Hibernian Society was to help fellow Irishmen get established in Savannah. Michael Dillon succeeded in his business to the point that in 1838, he lent John Guilmartin over $1,000 to get a small shipping business off the ground. The business venture was successful. Guilmartin became the eighth president of the Hibernian Society. (Courtesy Hibernian Society.)

The Kehoe family (as well as the Beytagh, Glass, Harty, Jaugstetter, Abbott, and Ritzert families) have the same family matriarch: Johanna Rath Kehoe. Born in 1806 in the Diocese of Ferns, County Wexford, Johanna married Daniel Kehoe around the age of 25. Nothing is known of Daniel's death, but on February 28, 1851, Johanna arrived at the port of Savannah with eight children, five boys and three girls, ranging in ages from 5 to 19. Two of her sons were elected to the Hibernian Society of Savannah, Patrick in 1878 and William in 1881, which indicates that they were a family of some means. (Courtesy Jack Jaugstetter.)

Four of Johanna's descendants became president of the Hibernian Society: William Kehoe, her great-grandson; John E. Jaustetter, her great-great grandson; and two great-great-great grandsons, Thomas J. Beytagh III and William J. Kehoe III. Pictured bringing the Hibernian banner into the cathedral for the Celtic Cross Ceremony are, from left to right, John J. Jaugstetter, David Sipple, Ted Haviland, and William Bruggeman. (Courtesy Paul Camp.)

Patrick Kehoe, Johanna and Daniel's oldest son, married Frances Murphy, also from Wexford, in Savannah at the Cathedral of St. John the Baptist on September 19, 1859. He served in the Confederate forces and was assigned to duty on the Savannah River, where he originally worked as a stevedore. After the war, he headed the shipping department of the Kehoe Iron Works until his death in 1911. (Courtesy Jack Jaugstetter.)

Johanna Eliza Kehoe, Patrick and
Frances Kehoe's daughter, married
Robert E. Jaugstetter in the Cathedral
of St. John the Baptist on August
31, 1902. She is shown here as a
young child and as a married woman.
(Both, courtesy Jack Jaugstetter.)

Robert E. Jaugstetter had Irish blood through his mother, Johanna Frost Jaugstetter, who was born October 12, 1854, to John Frost of Nova Scotia and Bridget Bryan of Wexford, Ireland. Johanna's parents were married at the cathedral by Savannah's first bishop, William Gartland, on July 21, 1853. Johanna married Frederick G. Jaugstetter, a native of Germany, at the Cathedral of St. John the Baptist in Charleston, South Carolina, on January 27, 1875. They were the parents of nine children. (Courtesy Jack Jaugstetter.)

Veronica Rahilly (left) and Mary "Mae" Rahilly DeBorde were twin girls born March 18, 1886, to Patrick Rahilly, a native of Ireland who migrated first to Quebec and then to Savannah, and Sarah Ellen McKenna, a native of Savannah whose parents, Felix and Margaret Welsh McKenna, were natives of Couny Monoghan and Tipperary, Ireland, respectively. Veronica never married. Mary married William Thomas DeBorde; they had 10 children. (Courtesy DeBorde family.)

Mike and Anna Fahey, shown here, had six children: Marie, Eddie, Tom, Lillian "Lila," Anne, and Mary Jane. Marie became Sr. Mary Conrad, and Eddie was grand marshal of the 2002 St. Patrick's Day Parade. Tom and Lila were both in the Navy in World War II. Lila was a nurse and Tom was an enlisted man on an aircraft carrier. Anne married Joseph Counihan and Mary Jane married Henry Brown. All the girls attended St. Vincent's Academy. (Courtesy Fahey family.)

Marie Fahey and her brother, Eddie, were stopped in the park one night by a man who wanted money. Without hesitation, Marie punched him out. She could be feisty, but she had a heart of gold. Her nephews loved her dearly, as she was as big a sports fan as they. (Courtesy Fahey family.)

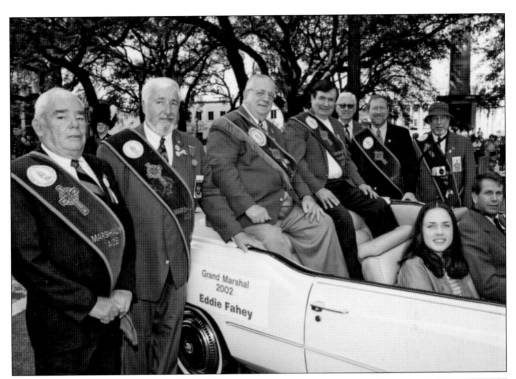

Seen in this image are, from left to right, Pat Dillon, Joe Counihan, Grand Marshal Eddie Fahey, Fr. Pat O'Brien, Tom Fahey, Chris Fahey, and Ed Fahey Jr. Catherine Counihan and the driver are in the front seat of the lead car in the parade. (Courtesy Parade Committee.)

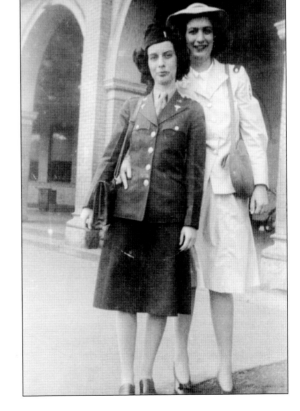

Lillian Fahey (left), an Army nurse during World War II, and Marie Fahey, a cadet nurse, are seen standing in front of the old Savannah Railroad Station. Lillian skipped her formal graduation from nursing school to enter the Army when World War II broke out. (Courtesy Fahey family.)

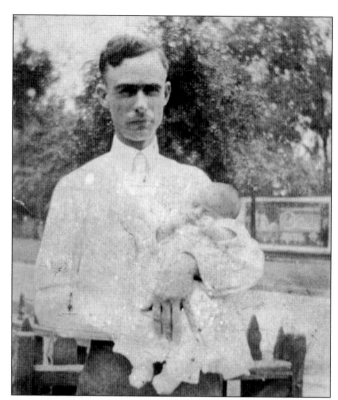

Mike Fahey holds his first child, Anna, in 1917. Mike was the first member of his family born in the United States and was orphaned at a very young age. (Courtesy Fahey family.)

The Fahey-Brown wedding took place on September 18, 1948. Members of the wedding party included, from left to right, Regina Brown, Tom Fahey, Ed Brown, Henry Brown, Mary Jane Fahey Brown, Anna Fahey Counihan, Louie Dismas, and Jo Fahey. (Courtesy Brown family.)

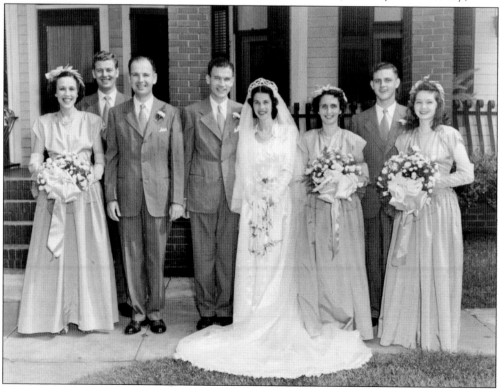

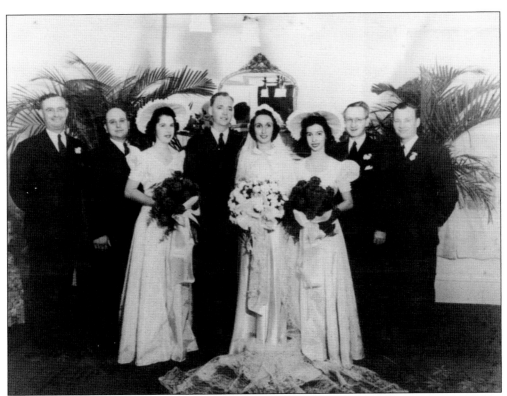

The Fahey-Counihan wedding party on October 30, 1941, was composed of, from left to right, Mike Fahey, Chris Solomon, Mary Jane Fahey, Joe Counihan, Anna Fahey Counihan, Lillian Fahey, William Walsh, and Michael Counihan. Anna chose to have a morning wedding followed by a brunch, which lasted well into the afternoon. (Courtesy Fahey family.)

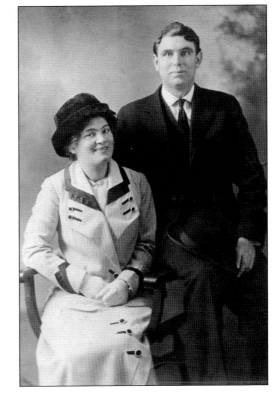

Quarantin lighthouse keeper Edward J. Fahey, brother of Mike Fahey, and his wife, Wilma, a native of Sweden, are pictured here in 1913. They had no children of their own, but the pair doted on Mike's family and always took the children to stay at the lighthouse during the summers. (Courtesy Fahey family.)

Mike's sister Lillian Fahey (pictured) went on to marry Alex McDonald. Mike named one of his daughters after Lillian. All his children were named for other relatives, as was the custom. Both Lillians were nurses. (Courtesy Fahey family.)

John and Elizabeth Giles Spellman arrived in Savannah from County Galway, Ireland, in 1847 with sons Martin "Murty," William, and John, and daughter Julia. John and his oldest son, Murty, first worked as laborers, but by 1860, John was a drayman and Murty was a ship carpenter. John and Elizabeth's son William married Katherine Rogers. (Courtesy Georgia Spellman.)

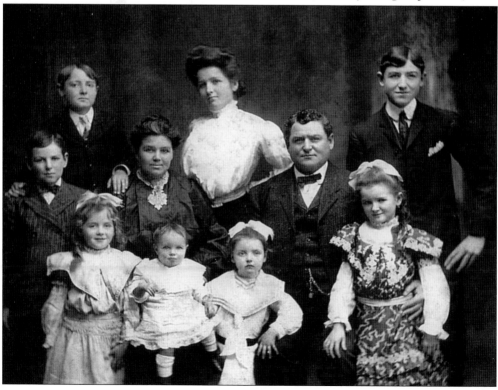

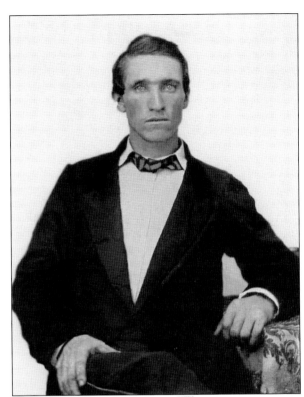

John Dennis Sheehan and Ann Mansfield both migrated to Savannah from Ireland via New York, but they met in Savannah and were married at the cathedral on January 8, 1860, by Rev. Peter Whelan. (Both, courtesy Georgia Spellman.)

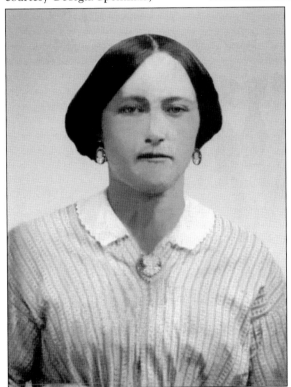

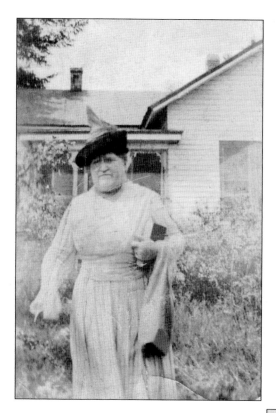

John and Ann's daughter Georgia married Thomas J. Ballantyne of Scotland on January 5, 1885. She is pictured here in her garden, which she loved to tend. (Courtesy Georgia Spellman.)

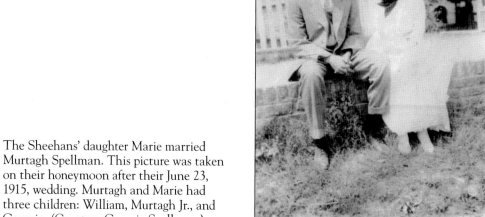

The Sheehans' daughter Marie married Murtagh Spellman. This picture was taken on their honeymoon after their June 23, 1915, wedding. Murtagh and Marie had three children: William, Murtagh Jr., and Georgia. (Courtesy Georgia Spellman.)

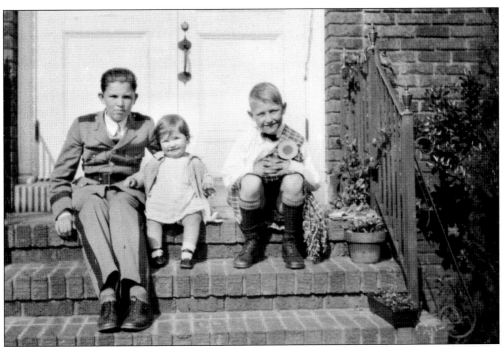

Shown here is an image of Marie and Murtagh Spellman's children. William is already in uniform and Murtagh Jr., "MA," looks ready to lead a parade. Georgia is just happy to be sitting on the front porch with her brothers. (Courtesy Georgia Spellman.)

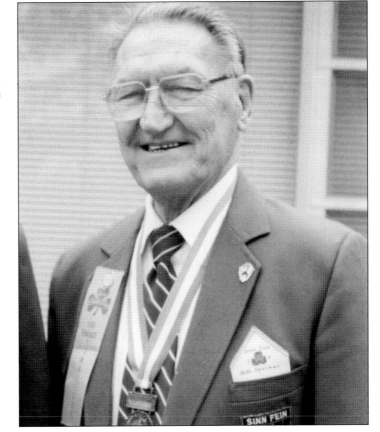

MA Spellman was the grand marshal of the 1979 St. Patrick's Day Parade. He had an extremely successful career as a football coach and PE teacher at Commercial High School. (Courtesy Georgia Spellman.)

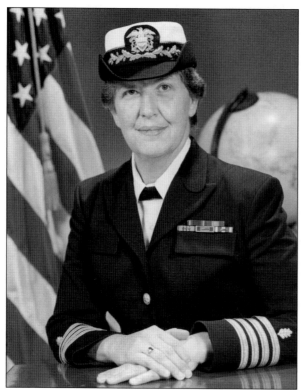

Georgia Spellman is a retired captain from the Navy nurse corps. She is a volunteer at the Diocese of Savannah Archives and a good resource for all things Irish. (Courtesy Georgia Spellman.)

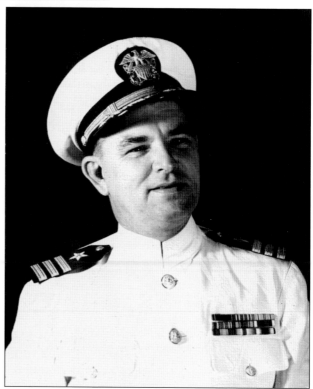

William Spellman is a retired US Navy commander. His son followed his Uncle MA's career path and is a high school principal. (Courtesy Georgia Spellman.)

Mrs. Joseph E. (Mamie) Kelly was the first president of the Catholic Women's Association. She is shown here at a banquet. (Courtesy Catholic Diocese Archives)

Below is an advertisement for Daniel O'Connor's business in the Savannah City Directory in 1870. Obviously, if it had to do with horses, Daniel was your man. Daniel's brother Patrick, also a wheelwright, owned a building at President and East Broad Streets, which was restored by Mills B. Lane in the 1970s. The O'Connor brothers, who were born in Wexford, Ireland, and came to Savannah, were descended from Roderick O'Connor (1117–1198), the last king of Ireland. Both brothers named their sons Daniel and Patrick. (Courtesy Genevieve O'Connor.)

# DANIEL O'CONNOR,

## HORSE-SHOER, WHEELWRIGHT,

### BLACKSMITH,

AND MANUFACTURER OF

## WAGONS, DRAYS, AND CARTS,

### NOS. 7, 9, AND 11 WEST BROAD,

Between Bryan and Chesnut streets.

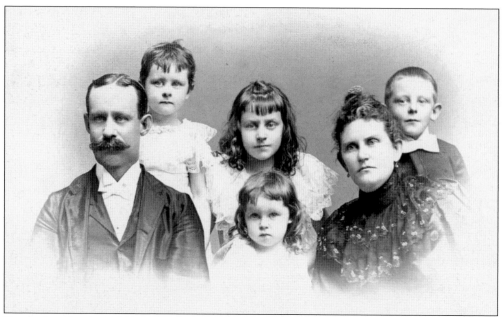

Pictured in this late 1800s O'Connor family portrait are, from left to right, (first row) Patrick, Josephine, and Winnifred; (second row) Winifred Maher, Norma, and David. Patrick Jr. was not born until 1902. (Courtesy Genevieve O'Connor.)

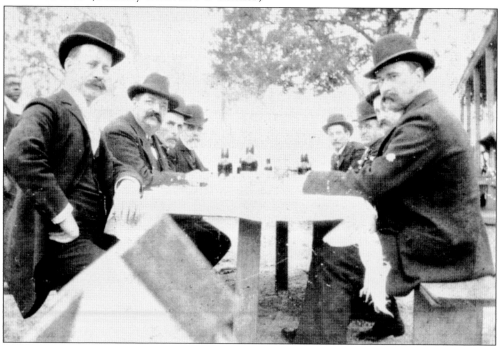

Daniel O'Connor's son Patrick became a respected lawyer, one of the best-known members of the Savannah Bar because of his connection with Irish fraternal orders. He headed the Ancient Order of Hibernians, the Irish-American Friendly Society, Catholic Knights of America, Irish Jasper Greens, and Robert Emmett Society, and was one of the oldest members of the Hibernian Society. Patrick is pictured here (seated, far left) on an outing with friends. (Courtesy Genevieve O'Connor.)

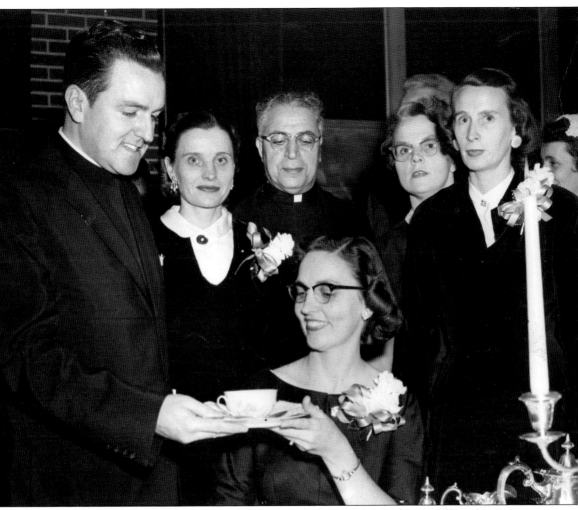

The O'Connors are not only descended from an Irish king, they are also related to the Queen of Southern Gothic, Mary Flannery O'Connor, who lived on Charlton Street as a young girl. In addition to her acclaimed writings, she also starred in a newsreel special with her pet chicken, which she had trained to walk backwards. This is believed to be a picture of Flannery (seated) at a tea at St. Joseph's church in Macon, Georgia. (Courtesy Diocese of Savannah Archives.)

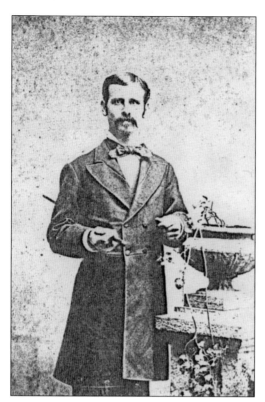

Richard Joseph Courteney (pictured here) and Lucy Mary Ellen Martin were both born in Ireland and came to Savannah with their families. Richard was the first chief conductor on the Central of Georgia Railroad. Lucy died after the birth of her last son, Charles. Ignatius, the oldest son, raised the rest of the children, as his father was away at work on the railroad much of the time. His sister, Agnes Theresa, kept house for them with the help of three servants. (Courtesy Sr. Susan Harms.)

Two of the Courteney boys became business owners. Richard Martin Courtenay owned a jewelry store on Bull and Broughton Streets. (Courtesy Sr. Susan Harms.)

Charles owned and operated Georgia Coal Company Household & Industrial Fuel, located at Atlantic Coast Line and Park Avenue. He married Gladys Arnold Johnstone in 1906. (Courtesy Sr. Susan Harms.)

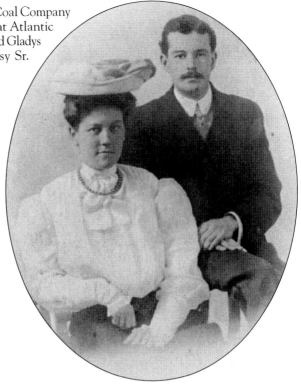

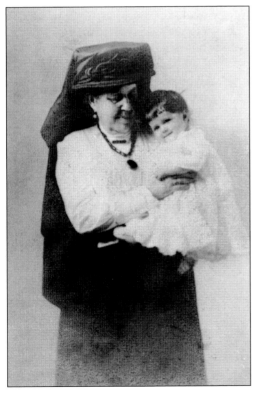

Susan Arnold Johnstone holds her granddaughter, Gladys Johnstone Courtenay. Later, Gladys would name her only child after her grandmonther. (Courtesy Sr. Susan Harms.)

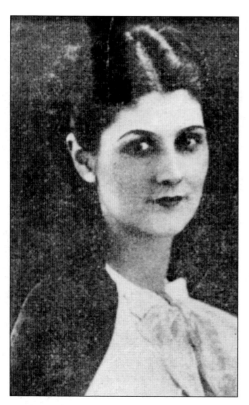

Gladys is shown here in the announcement of her marriage to Ernest "Pete" Harms. Gladys and Pete had one daughter, Susan Arnold Harms, who became one of our current "Savannah Irish" nuns, Sr. Mary Susan. Sister Susan teaches first grade at St. Peter's Catholic School; she recently celebrated her 50th anniversary as a Sister of Mercy. (Courtesy Sr. Susan Harms.)

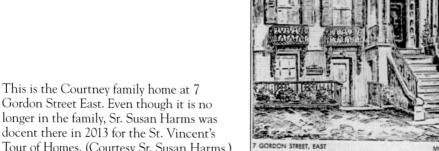

7 GORDON STREET, EAST                    MONTEREY SQUARE

This is the Courtney family home at 7 Gordon Street East. Even though it is no longer in the family, Sr. Susan Harms was docent there in 2013 for the St. Vincent's Tour of Homes. (Courtesy Sr. Susan Harms.)

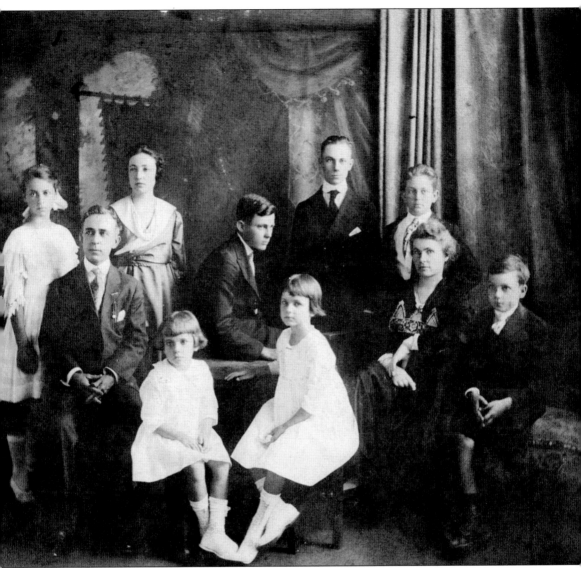

It was in vogue to have family portraits taken at home in the early 20th century. Pictured in this Collins family portrait are, from left to right (first row) Josephine Collins Grevenburg and Mary Collins Ciucevich; (second row) John T. Collins, Walter Collins, Mary Catherine Collins, and Frank Collins; (third row) Helen Collins Keating, Margaret Collins, James J. Collins, and John T. Collins Jr. (Courtesy Cecilia Courtenay.)

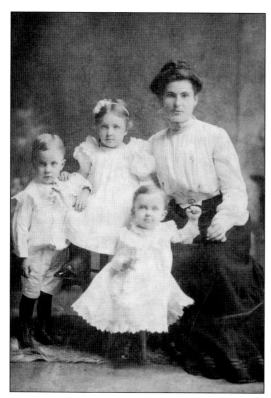

Mary Catherine Collins and her three children are pictured here around 1900. Jimmy and Margaret, the twins, are in back and Johnny is in front. Pictures of mothers with children were common, but pictures of just the father with the children were rare. (Courtesy Cecilia Courtenay.)

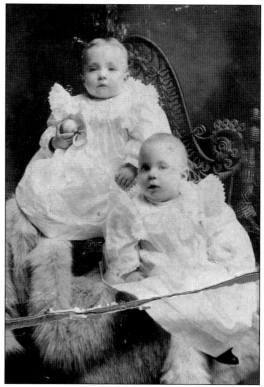

Mary Catherine had her hands full with her twins, Margaret and James J. (Jimmy) Collins, who were born March 10, 1899. (Courtesy Cecilia Courtenay.)

Cecilia Cassidy Collins enjoys a luncheon party prior to her 1929 wedding. It was a common practice to have parties written up in the newspaper with detailed information, down to a description of what guests of honor wore. (Courtesy Cecilia Courtenay.)

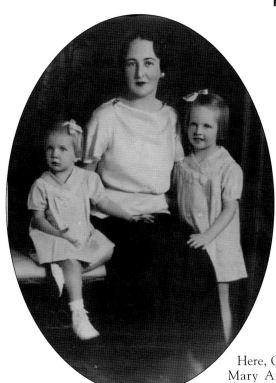

Here, Cecilia is pictured with her two daughters, Mary Ann Collins Butler and Cecilia Collins Courtenay, around 1934. (Courtesy Cecilia Courtenay.)

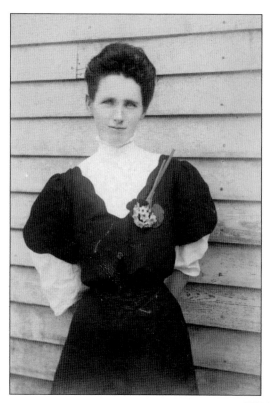

Evalina "Lena" Marr Counihan was known for her elderberry wine. Little old ladies who would never touch a drop of the "hard stuff" loved her wine and never understood why they were so giddy after a small glass. Lena's secret was that she put a few elderberries in her moonshine. Aunt Lena, so called because all the children in the Old Fort gathered at her house, raised nine children after her husband died. The older ones helped with the younger ones and the family motto was, "Brothers and sisters have to take care of each other." (Courtesy Counihan family.)

The Counihan sisters—Agnes Lamb (front row, with niece Sheila Counihan) and, from left to right in back, Evelyn, Margaret, Ann, and Mildred—were always known as "the girls" even after some of them married. They are pictured here at a Savannah Sugar Refinery picnic around 1946. (Courtesy Counihan family.)

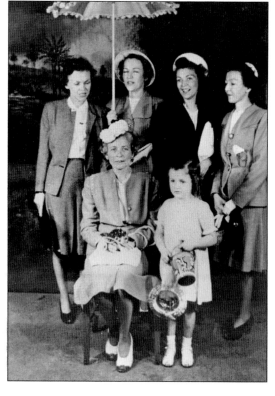

Brothers John, Michael, and Joe Counihan bought beachside lots at the north end of Tybee and enjoyed many summers there. John (left) and his nephew Jerry Counihan (right) lived on the portion of the property called Counisle. (Courtesy Counihan family.)

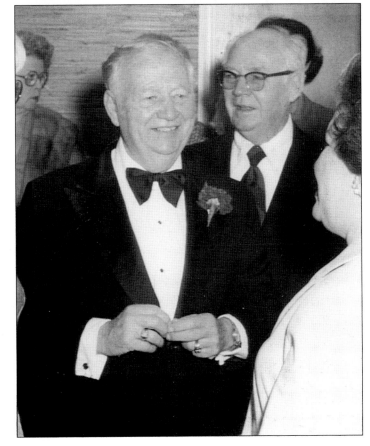

Brothers Mike and Joe Counihan each had a son the same age, Joe and Jerry. In this image, Mike and Joe are seen mingling at Jerry Counihan's wedding. (Courtesy Counihan family.)

Aunt Lena had her hands full with three boys who were close in age. John, being the oldest, worked to support the family. Michael, Dennis, and Joe are shown barefoot below in a 1920 photograph and dressed up at left in a later one. However, they appear to be up to mischief in both. (Courtesy Counihan family.)

Margaret Counihan Walsh became a nurse and her niece Carroll Lamb Kelly followed in her footsteps. Margaret (pictured here) remained the family health expert until her death. (Courtesy Counihan family.)

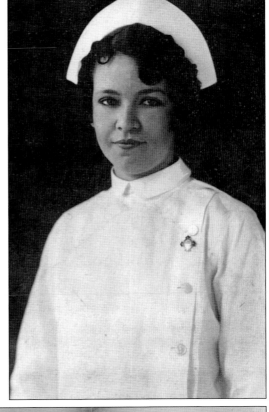

Anne Counihan became a beautician, and all her nieces remember having their hair put up in rags so they could have Shirley Temple curls. She is pictured here (on the right, facing the camera) in her shop, Chez Jozie, around 1932. Anne loved a good time and in later years traveled for Tooley Myron Photographers. She would always say, "Darling, I've had a good life." (Courtesy Counihan family.)

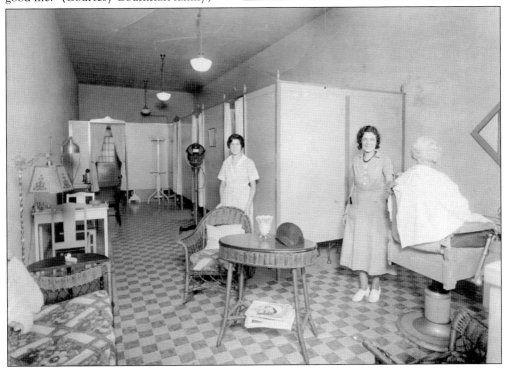

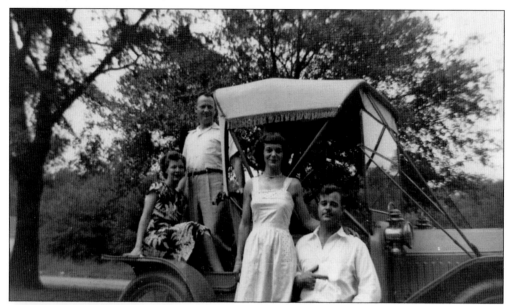

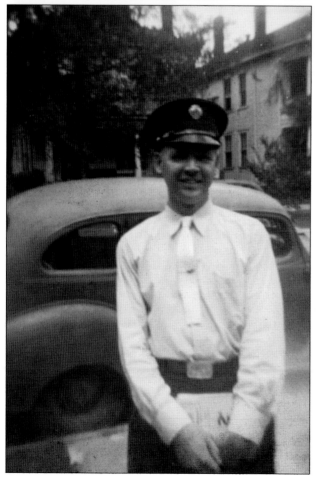

Brothers married sisters in the Counihan and DeBorde families. In this 1938 picture are, from left to right, Ann Counihan DeBorde, Michael Counihan, Sarah DeBorde Counihan, and Johnny DeBorde. They are riding in a car with fringe on top. (Courtesy Jerry Counihan.)

Joseph Patrick Counihan Sr., seen in this c. 1940 photograph, was a lieutenant in the Savannah Fire Department and retired as a captain. He worked at the historic Station No. 1. (Courtesy Counihan family.)

# *Two*

# IRISH LOVE THE BEACH

Some Irish families have had homes at Tybee Island since the early 1900s. Even with fair skin, the Irish love the sun and surf. Those who didn't own homes would try to rent a house or apartment for at least a week during the summer. Even on vacation, Sunday Mass was obligatory. During the summer, St. Michael's Church was always packed and hot, as it wasn't air-conditioned in the early days. The sound of the rotary fans on the wall and the swish of people using the funeral home paper fans often drowned out the sermon.

For years, the only way to get to Tybee was by train. Many a young person would arrive at the last train leaving Tybee on Saturday night, running as fast as possible because after that train left, there was no way to get home and no way to contact anyone. Riding the train was part of the adventure of Tybee. Families would bring huge picnic baskets to the Tybrisa Pavilion to picnic in the shade. There were bathhouses where one could change clothes, as well as a bowling alley and an amusement park on the strand. Of course, there were also food stands and bars and benches along the strand, where the adults would sit as the children raced from one activity to another, the sound of the calliope on the merry-go-round filling the air.

Tybee is such a part of Savannah Irishmen's lives that in 2002, a second parade was started at Tybee. Not wanting to miss an extra party, the Irish decided that it would be held on the Saturday preceding March 17 and be called the Irish Heritage Parade. Like the island itself, this parade is very laid back and spectators are likely to become marchers with a little encouragement.

Antoinette and Mike Ryan enjoy the laid back Tybee Parade. Many Irish organizations come march or ride in this parade, and there is always a party (or two) afterwards. (Courtesy Antoinette Ryan.)

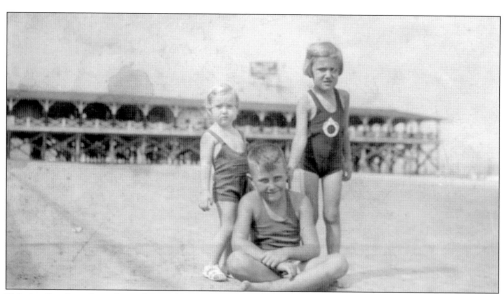

Tybrisa Pavilion has always been the centerpiece of Tybee Island. At one time, there was a skating rink, food concessions, and bars. Many summer theater groups have performed on the pavilion, and fishermen enjoy going out on the pier. Here, from left to right, Kitty Browne Hernandez, Bartie Shea, and Mary Shea Hinkle enjoy a day at the beach. (Courtesy Kitty Hernandez.)

Members of the Collins family are years too early for the Tybee St. Patrick's Parade but would certainly have been a great addition. Pictured from left to right on a roadster are (first row) John T. Collins Jr., Mary Collins Ciucevich, Helen Fleetwood Collins, Josephine Collins Grevenberg, James J. Collins, and Frank Collins; (second row) "Chicken Little," Walter Collins, and Frank VanGeesen. (Courtesy Cecilia Courtenay.)

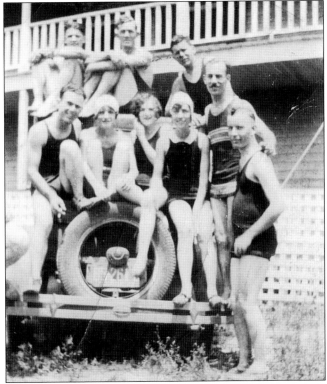

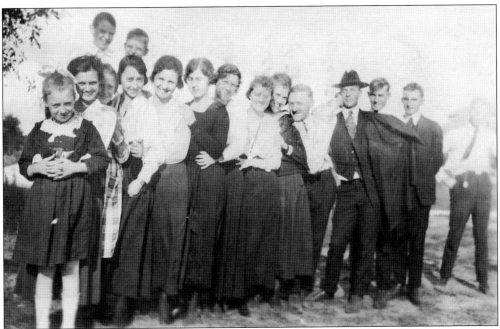

The Shea family enjoyed family gatherings at Tybee. Pictured here in the first row from left to right are Kitty Shea Witmer, Esther Berry, Mary Harris, Mel Browne, Florence Street, Florence Straight, Mildred Browne Wheeler, Marie Shea Browne, Terry Wheeler, Walton Bryant, Dewey Williams, Steve Kutchey, George Browne, and unidentified. (Courtesy Kitty Hernandez.)

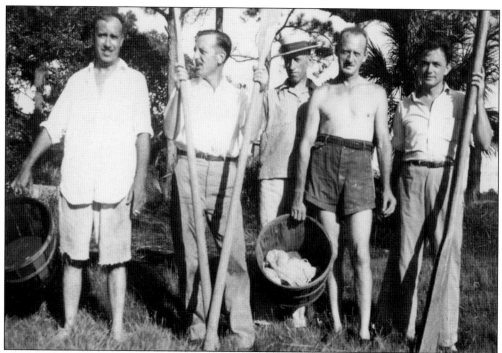

Many Irish fished for a living in Ireland, so catching a "mess" of crabs for dinner comes naturally to them. Bart Shea, Guy Witmer, Jim Shea, George Browne, and Bob Downing are ready to get in their *batezu*. (Courtesy Kitty Hernandez.)

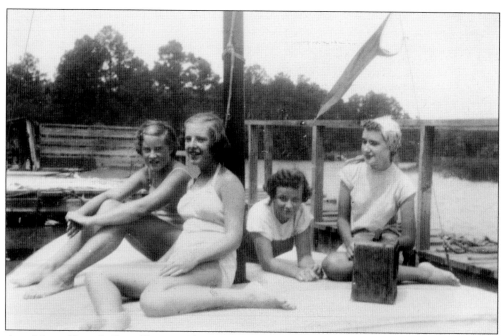

Ann Marie Shea Collins, Eleanor Gleaton, Carolyn Redmond Groover, and Mary Shea Keane are probably using baby oil and iodine to tan their Irish skin. They are enjoying "the Camp," which was a former Girl Scout camp. (Courtesy Kitty Hernandez.)

Katherine "Kate" Shea enjoys a rare moment of quiet in her parlor at Tybee around 1943. Many Shea children and friends played in that parlor on rainy days. Notice the picture of the sailor on the wall; it is a photograph of one of her sons. (Courtesy Kitty Hernandez.)

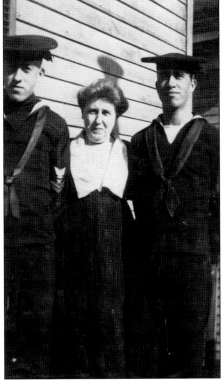

Long before Kate Shea hung the pictures of her two sons in the Navy on her wall, she spent days crying because the two boys, Bart (left) and Jim were afraid to tell her they wanted to "join up." (Courtesy Kitty Hernandez.)

The Shea boys, Bart (left) and Jim, left their mother a note telling her that they had run away to join the Navy. Fortunately, they both survived World War II. (Courtesy Anne Marie Collins.)

Marie Shea Browne and her cousin Owen Kelly are shown here. Apparently, the family favored the Navy. (Courtesy Kitty Hernandez.)

George Edwin Browne didn't "become" Irish until he married Marie Shea but, as indicated by his hunting dog and gun, he apparently had some Irish inclinations at an early age. (Courtesy Kitty Hernandez.)

When they weren't at the beach, home was 415 East Anderson Street for young Marie Shea Browne and Kitty Shea Witmer. They liked to sit on the front porch and watch neighbors go by. (Courtesy Kitty Hernandez.)

Bart Shea Jr. (left) was a Navy corpsman in World War II. He, at least, told his mother before he joined up, unlike Kate Shea's sons. (Courtesy Anne Marie Collins.)

Sitting on the steps of their Tybee house in 1923 are, from left to right, (first row) Kitty Shea and Bart Jr.; (second row) Bart Shea, Ernestine Summers, and Kate Shea. Summers at Tybee never seem to change. (Courtesy Kitty Hernandez.)

The Shea family is all dressed up for Tybee. This picture was taken at the Sacred Heart Church Picnic at Tybee in June 1901. (Courtesy Kitty Hernandez.)

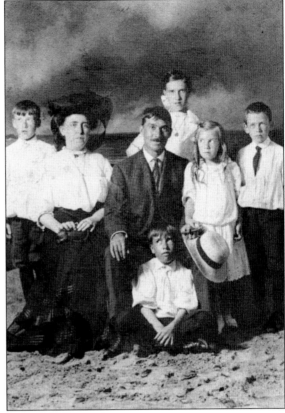

Living on the North End of Tybee means there isn't much excitement, so Joe Counihan was delighted when his cousin Joe Kelly landed in a helicopter. Ever the perfect Irish gentleman, Joe Counihan (left) greeted Joe Kelly with a beer. (Courtesy Counihan family.)

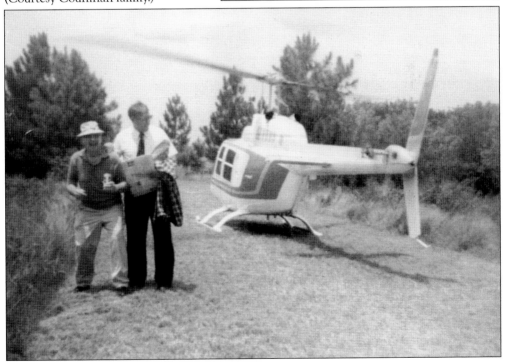

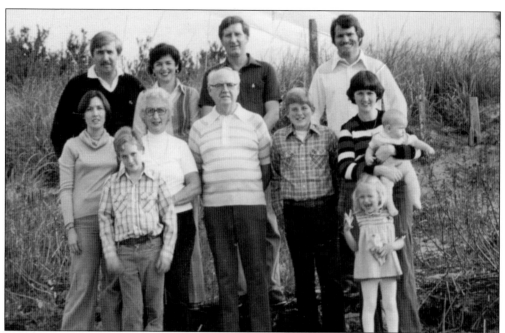

Joe Counihan named his beach house Shandejo, which was formed by using the first two letters of each of his children's names. Pictured here from left to right are (first row) Kevin Winders and Shelley Carroll; (second row) Anne, Anna, and Joe Counihan, Ronnie Winders, and Deborah Carroll holding Joe Carroll; (third row) Joe Counihan Jr., Sheila and Ron Winders, and Bill Carroll. Tragically, Anne was killed in an automobile accident months after this picture was taken in 1988. (Courtesy Counihan family.)

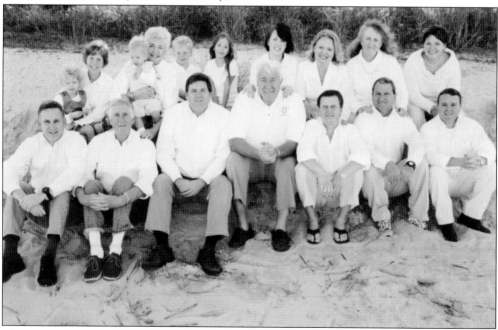

The Counihan family sold their beach property in 2005, but they took one last family portrait on the beach that was so loved by their parents. (Courtesy Counihan family.)

On February 24, 1929, Helen Tobin took this picture of the Lucky Strike Club at Tybee. Other members included Mary Dyer, Mary Kearney, Josephine Mitzler, Cecelia Fitzpatrick, and Nellie Murphy. (Courtesy Cecelia Gavin DeBorde.)

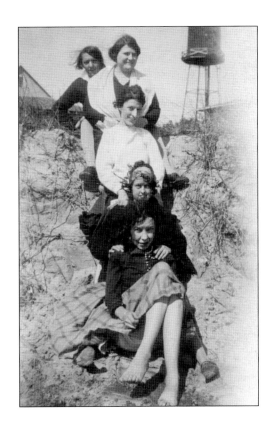

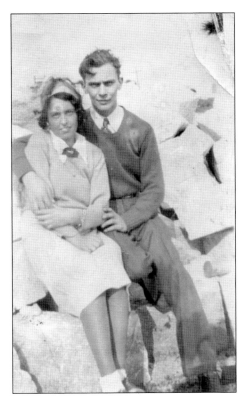

Cecelia Fitzpatrick and Richard Gavin pause for a courtship picture in 1930. The beach has always been a favorite place for couples. (Courtesy Cecelia Gavin DeBorde.)

William and Nonie Fitzpatrick sit on the porch of their Tybee cottage with granddaughter Patty Gavin in 1935. Many Irish families either owned cottages at Tybee or rented them for the summer. (Courtesy Cecelia Gavin DeBorde.)

From left to right, Margaret Smith, Mary O'Hayer, and Mary White are true ladies in waiting in this 1938 photograph. It looks like they will need more than one stroller, though. (Courtesy Cecelia Gavin DeBorde.)

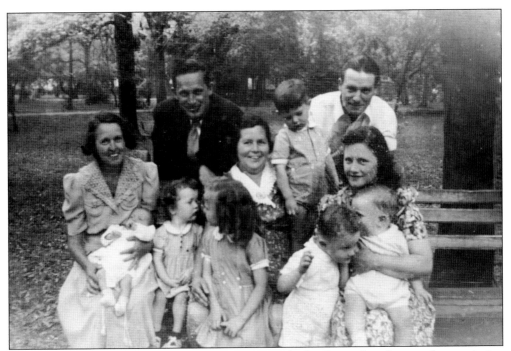

By 1942, that stroller had been filled more than once. The families in this photograph are enjoying spring in Forsyth Park, one of Savannah's treasures. (Courtesy Pete Gavin DeBorde.)

Gertrude and Richard Gavin enjoy the beach on Tybee Island in June 1945. Their son Richard Jr. married Cecilia Fitzpatrick. (Courtesy Cecelia Gavin DeBorde.)

Gertrude and Richard Gavin (center, both rows) celebrate Christmas with their four sons—from left to right, Gene, Art, Richard Jr., and Gerald—in 1938. Gertrude was always happiest when she had all her boys home. (Courtesy Cecelia Gavin DeBorde.)

 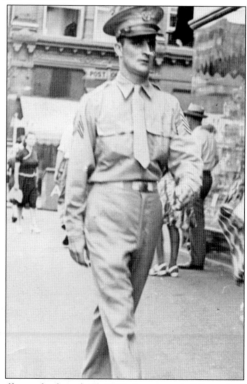

At left, Jo Rhemler and Gertrude Gavin enjoy a walk on the beach in 1945. It was probably a good way to have some quiet time. At right, Gene Gavin was on leave when a street photographer took this picture in 1942. Street photographers were very common in downtown Savannah during this time. (Both, courtesy Cecelia Gavin DeBorde.)

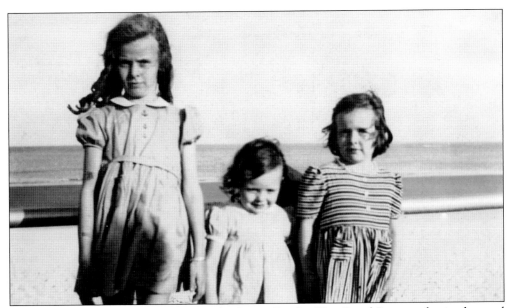

The three Gavin girls—from left to right, Patty, Cecilia "Pete," and Peggy—play in the sand on Tybee Island in 1945. There is probably a grandmother watching close by. (Courtesy Pete Gavin DeBorde.)

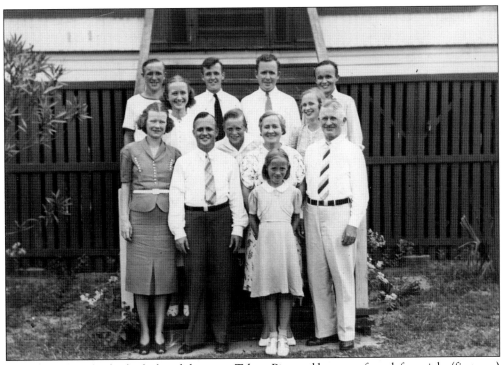

The Powers family also had a beach house at Tybee. Pictured here are, from left to right (first row) Mary; (second row) Margaret, Richard, Loretto, and Charles; (third row) Sr. Felicitas, Terry, and Marianna; (fourth row) Robert, Gene, Charles Jr., and John. (Courtesy Powers family.)

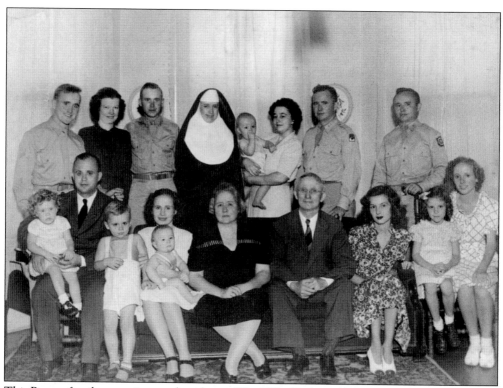

This Powers family portrait was taken during Word War II when all the boys were home on leave. Richard tried to join the Army but was rejected because he had an enlarged heart. He tried to explain that he was a long distance runner in college and was in great shape, but they wouldn't listen. From left to right are (first row) Loretto being held by Richard Powers, Arnie Seyden Jr., Marianna Powers Seyden holding Charles Seyden, Loretto, Charles, and Marilyn, Elizabeth, and May Powers (second row) Robert, Margaret, and Terence Powers, Sr. Felicitas Powers, Charles Powers III held by Pearl, Charles Jr., and John Powers. Richard's wife, Margaret, always said the first thing she noticed about him was his "Charles Boyer eyes." (Courtesy Powers family.)

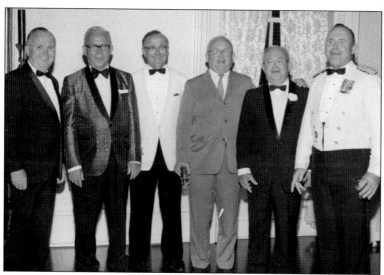

The Powers boys, thankfully, made it back from the war. From left to right are Gene, Charles Jr., Robert, John, Richard, and Terry Powers at a family wedding. (Courtesy Powers family.)

# *Three*

# IRISH CHURCH
# AND SCHOOL

For the uneducated Irish in the 1800s, here and in Ireland, chances were that the parish priest was the writer and reader of letters sent across the sea. The Catholic Church played a large part in the lives of the immigrants in Savannah. There were many good Irish priests who ministered to their flocks and many unselfish Irish women who came to educate children in the Catholic schools. For a long time, Irish and clergy were interchangeable words in Savannah. Sadly, the last of those adventurous young men who crossed the sea from Ireland, ministered to the Savannah Irish, and, ultimately, became Savannahians and citizens of the United States are now coming close to their retirement. The banner has been taken up by some native-born Savannah Irish, but they are few.

The same story is true for our Irish nuns. Up to the 1950s and early 1960s, many young women contemplated the religious life and many Savannah Irish young women joined religious orders. Today, this is rare.

Ireland now has one of the best-educated workforces in Europe, but the immigrants who came to Savannah did not have that advantage. Perhaps it is because of this that they insisted on good schools for their children. Some of the earlier schools, like the Marist Brothers' School, are gone, but there are still "Marist Boys" to tell tales of being taught by the brothers. Another school no longer in existence is St. Patrick's School. It has an interesting history, in that it was located on property with St. Patrick's Catholic Church but was not a Catholic school. It was staffed with Catholic teachers and named for Savannah's favorite saint, but it was a public school. Savannah/ Chatham County opened it as an experiment. This certainly shows the effect the Irish community had at this time.

As time passed, more Catholic grammar schools opened, but Benedictine and St. Vincent's Academy remained the only secondary schools. It is inspiring how much Catholic parents sacrificed to send their children to Catholic school. This was true even in earlier days, when few people had much money to spare; it continues to be true, even with recent economic disasters.

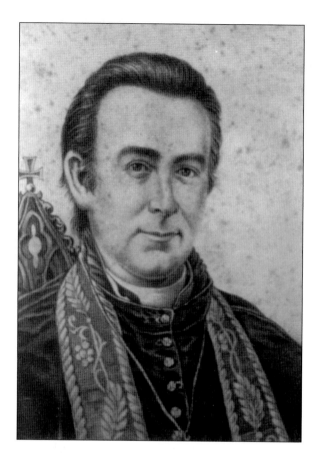

Bishop Francis Xavier Gartland of Dublin was the first bishop in Savannah. He was devoted to his flock and tended them tirelessly during the yellow fever epidemic and ultimately died of the fever himself. There is a service award named after him given to deserving recipients from each parish in Savannah yearly. (Courtesy Diocese of Savannah Archives.)

Fr. Jeremiah O'Neill was not only a wonderful spiritual leader but also a wise community leader. He worked at maintaining a good relationship between his Catholic community and the predominately Protestant city. Father O'Neill's first concern was church affairs. He raised funds for the new cathedral in the 1830s, did missionary work in Catholic outposts, and also arranged for the Sisters of Mercy to take over the new orphanage he was building. Additionally, he recruited workers among his Irish congregation to meet the community's labor needs and worked closely with the Central of Georgia Railway. He also intervened with labor problems. He likely would have made as good a politician as he was a priest. (Courtesy Diocese of Savannah Archives.)

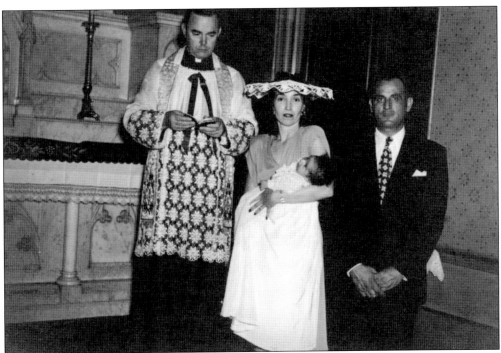

It is considered one of the highest honors an Irishman can receive to be elected grand marshal of the St. Patrick's Day Parade. Four clergymen have received this honor, which is most unusual, as normally a priest will be asked to be chaplain. These priests were overwhelmingly popular with not only their congregation, but the entire city. Msgr. T. James McNamara (Monsignor Mac to his parishioners), rector of the cathedral, was elected grand marshal in 1967. He was a Savannah-born Irishman and knew his congregation so well that he recognized voices in the confessional. Imagine the shock when, after being given absolution, Monsignor Mac would inquire about the health of the penitent's family. Here, he is baptizing a baby. (Courtesy Diocese of Savannah Archives.)

Even though he was popular with both Catholics and non-Catholics, it was really a surprise when a priest was made grand marshal. Monsignor Mac took a great deal of kidding at his investiture. (Courtesy Diocese of Savannah Archives.)

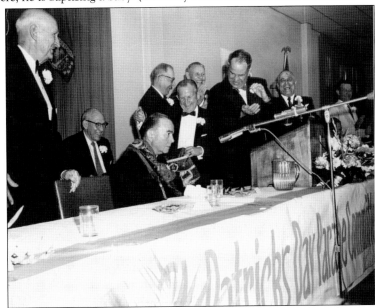

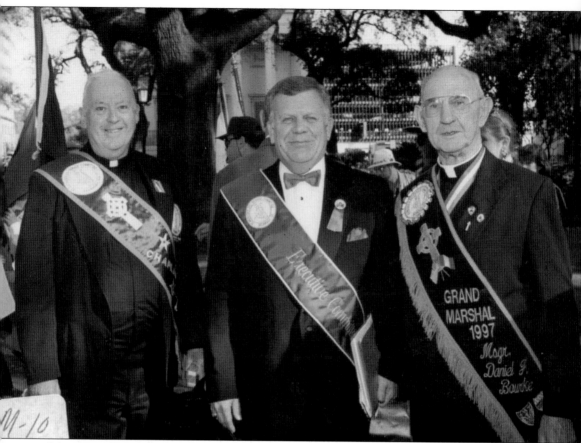

Msgr. Daniel J. Bourke (right) was the grand marshal in 1997. Monsignor Bourke came to Savannah as a young priest and gave 110 percent of his energy to Savannah, even becoming a citizen, but his heart never let go of Ireland. He was much loved by all and it was fitting that he chose men far younger than he to be his aides, showing that he was truly a man for all seasons. He is featured in one of Bill Harris's novels. He is shown here with Fr. Joe Ware (left) and Frank Baker of the Parade Committee. (Courtesy Savannah Parade Committee.)

Fr. Joseph F. Ware (left), another Savannah Irishman, was elected grand marshal in 2004. He had the true dry Irish wit and his collection of books on religion and Ireland filled his brother Mike's garage when he retired. He was the Parade Committee Chaplain and would go with the committee to Atlanta each year to meet with the Georgia legislature to promote the St. Patrick's Day Parade. Father Ware loved working in the archives and had a large personal collection of Irish works. He is pictured here with two of his aides, his brother Mike (center), and Jimmy Quigley. (Courtesy Ware family.)

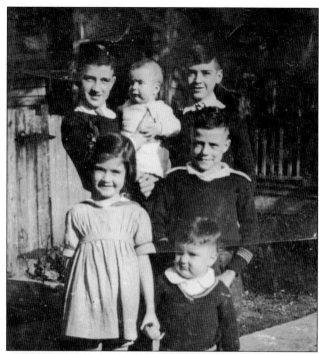

Father Ware's mother was Mary Whalen, and his grandfather was Thomas Whalen. While most of the Savannah Whalens now spell the name "Whelan," there is a Thomas Whalen of the same family who lives in Savannah today. The Ware children are shown here from left to right: (first row) Rosemary, Tommy, and Jerry; (second row) Jack (holding Mike) and Father Ware. (Courtesy Ware family.)

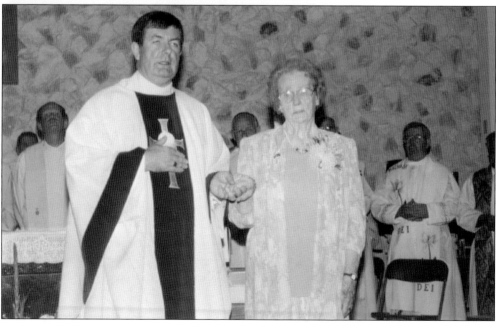

Fr. Patrick O'Brian, a native of Cork, Ireland, became a US citizen and not only served as pastor of St. Peter the Apostle Church but was also instrumental in renovating Nativity of Our Lord and then building St. Peter's church and school. In his "spare time," he served as chaplain to the Chatham County Police. He was elected grand marshal for the 2008 parade. Father O'Brian celebrates his 25th anniversary as a priest in this 1994 photograph. His mother, Mary Ellen O'Brian, came from Ireland for the happy celebration. Mary Ellen made many friends in Savannah and the parish always looked forward to her visits. (Courtesy Diocese of Savannah Archives.)

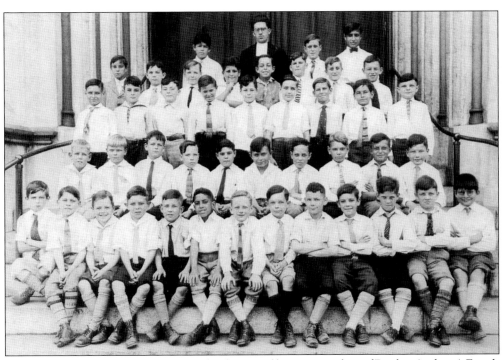

The Marist School was a boys' grammar school. Pictured here are members of Brother Anthony's Fourth Grade in 1926–1927. From left to right are (first row) Joseph Mell, Louis Frizzell, Eugene Powers, Aloyisus Handiboe (who wrote the song "St. Patrick's Day in Savannah"), Angus Haynes, Nathan Thomas, John Davis, Arthur Sanders, Benito Sieg, Fred Doyle, Robert O'Brien, William Reilley, and Jerome Pinckney; (second row) Edward Shepherd, Turner Wilson, Jack Schley, Dennis Counihan, George Peters, Gus Robertson, Robert Marsden, Joseph Battle, Norbert Green, and Henry Brown; (third row) Henry Schroder, William Brown, Richard Walsh, unidentified, Jack Brophy, Robert Marsden, William Murrin, Robert Alonso, and Jack Stafford; (fourth row) Edward Cetti, Samuel Lynch, Joseph Counihan, Andrew Aprea, James Schuler, William Ryan, Charlton Murphy, and James Rossiter; (fifth row) Joseph Flaherty, Brother Anthony, Joseph Murphy, and Savo Romano. (Courtesy Counihan family.)

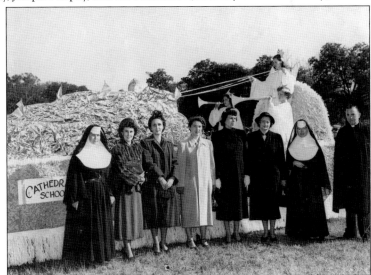

The Cathedral Day School was well supported by cathedral families. Pictured here is the Christmas float committee in 1948 with Monsignor McNamara. Anne Counihan and Angela Winders are pictured third and fourth from left. The school also held a Christmas pageant, which was always well attended. (Courtesy Counihan family.)

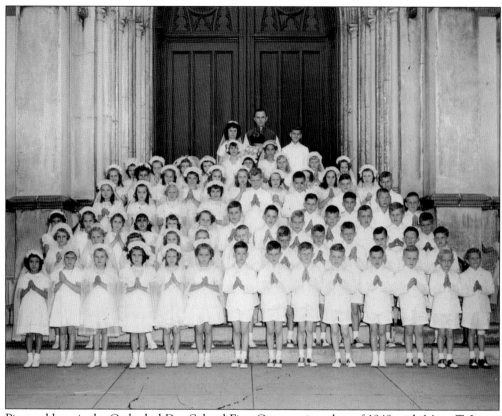

Pictured here is the Cathedral Day School First Communion class of 1949 with Msgr. T. James McNamara. Many Irish surnames pop up in this group: Rossiter, Counihan, Leonard, Russell, O'Hayer, Finnegan, O'Driscoll, Buttimer, Blair, and Roughen, just to name a few.

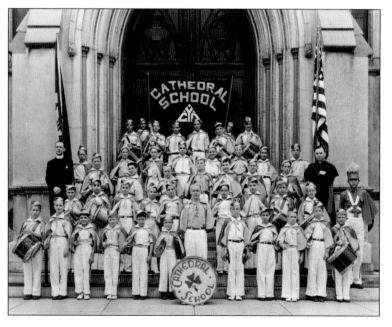

The popular Cathedral Day School band marched in the St. Patrick's Day Parade. There is a shamrock on the drum, indicating that this was before Blessed Sacrament School opened in 1934, as Blessed Sacrament uses the shamrock as its symbol. (Courtesy Diocese of Savannah Archives.)

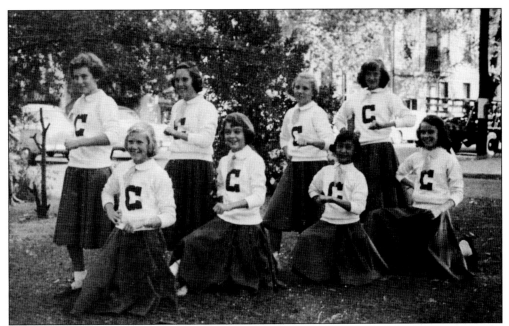

In the 1950s, schools played in a Catholic league. These Cathedral Day School cheerleaders from 1954 cheered for football and basketball. From left to right are (first row) Margie Russell, Betty Finnegan, Julie Hernandez, and Betty Finnegan; (second row) Patricia Kelly, Cathy Blair, Trudy O'Hayer, and JoAnn Leonard. (Courtesy Diocese of Savannah Archives.)

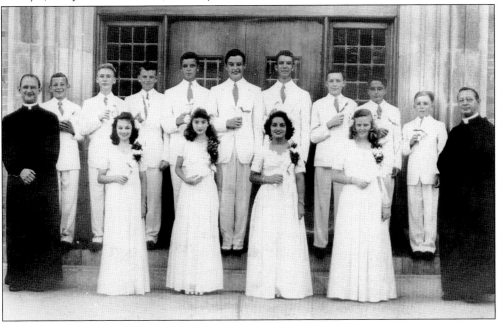

This is the first graduating eighth-grade class in 1944 from Blessed Sacrament School on Victory Drive. From left to right are (first row) Father Burke, Jane Redmond, Patty Quinan, Monica Ulivo, Cecilia Collins, and unidentified; (second row) Billy Kenny, Frank Coyle, Joe Brown, Billy Aeger, Richard Curry, Charlie Aeger, Harty Keating, Joe Tilton, and Gordon Whelan. (Courtesy Diocese of Savannah Archives)

St. Vincent's Academy for Girls opened in June 1845. Sisters of Mercy from Charleston, South Carolina, under the leadership of Mother Vincent Mahoney, began a boarding school, orphanage, day school, and free school. St. Vincent's Convent became an independent Motherhouse within two years; from here, over 20 schools, hospitals, and orphanages were founded throughout Georgia. Records attest to the bravery and heroic service rendered by the Sisters of Mercy during the yellow fever epidemics of 1853, 1876, and 1878, and to their care for the wounded and suffering during the Civil War. Students at St. Vincent's include Winnie and Jeff Davis, children of Confederate president Jefferson Davis. (Courtesy St. Vincent's Academy.)

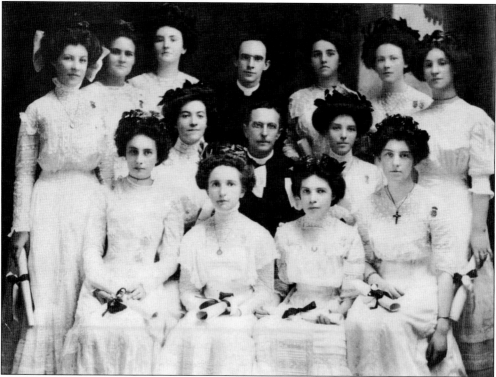

The St. Vincent's Academy class of 1909 included, from left to right, (first row) Loretta Whelan, Nellie Price, Helen Doyle, and Jessie Jacobs; (second row) Annie McPhalen, Msgr. Joseph Miletate, and Alice Price; (third row) Marie Blackwell, Josephine Leary, Nellie Donlevy, Fr. Schadenell, Katie Joyce, Mary Altick, and Marguerite Lyons. (Diocese of Savannah Archives.)

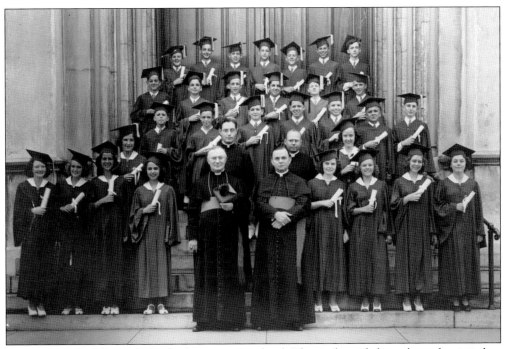

At one time, St. Vincent's also had a grammar school. This is the eighth-grade graduating class of St. Vincent's Grammar School in 1936. (Courtesy Fahey Family.)

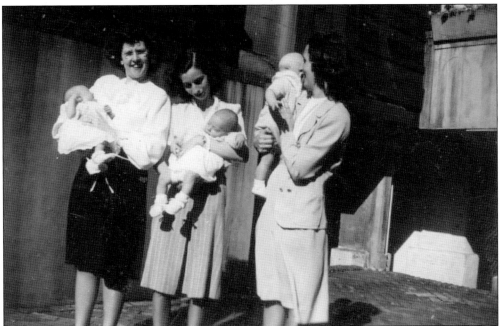

The St. Vincent's Academy (SVA) girls bonded closely with the Mercy nuns who taught them. Each May, the nuns would host a tea and alumni would attend with their small children. This was a great time for alumni to see each other and their teachers and to show of their beautiful offspring. Lillian Fahey Clark is shown in the middle with her young son, Buddy. Two of her classmates show off their babies as well. (Courtesy Clark family.)

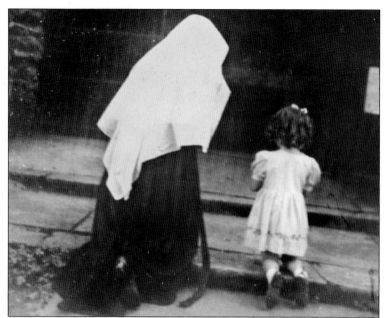

Nuns wore the habit at that time, which could be scary to young children. However, at these teas, the children got to know the sisters, which made their entry into school later much easier. The most telling relationship is shown in this picture of a nun and small girl praying at the grotto. (Courtesy Counihan family.)

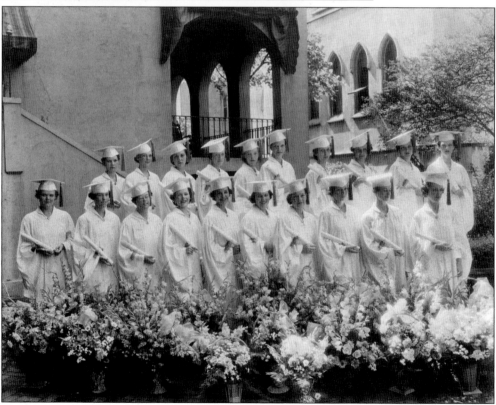

The SVA class of 1935 was the first to hold graduation in the cathedral. Prior to that, the school used Lawton Auditorium. At that time, the cathedral gave plenty of room for friends and family. Now, classes are so large that graduation is a ticket-only affair, but holding it in this beautiful church makes it worth it. (Courtesy St. Vincent's Academy.)

As St. Vincent's Academy grew in size, expansion was necessary. Sadly, this beautiful chapel, which was reached by climbing golden oak stairs, was demolished to make room for more classrooms. (Courtesy Diocese of Savannah Archives.)

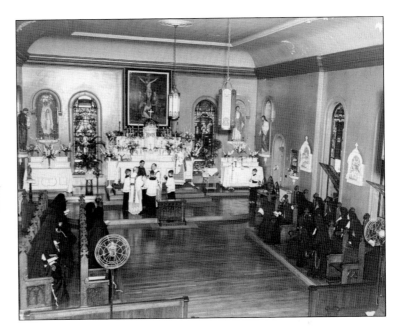

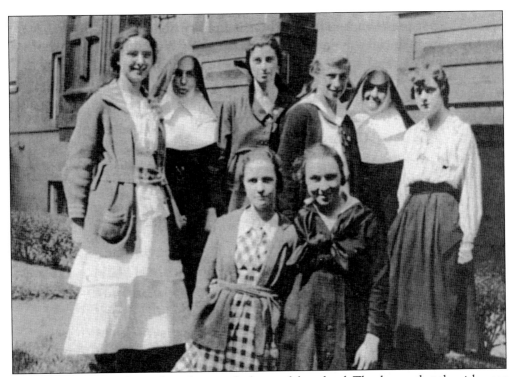

St. Vincent's students have always been at the heart of the school. The dresses that the girls wear today may be different, but the class of 1919, seen standing in a courtyard, looks similar to classes today. (Courtesy St. Vincent's Academy.)

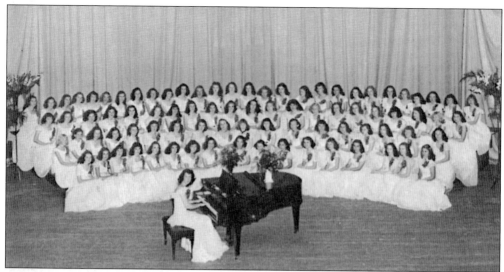

Music has always been a part of St. Vincent's. The school held an annual Glee Club concert for many years, ending in 1960. Patty Barragan Schreck and her sister, Sr. Mary Fidelis, were instrumental in making the music program the success it is today. Patty Barragan is shown here playing piano for a concert in 1948. (Courtesy St. Vincent's Academy.)

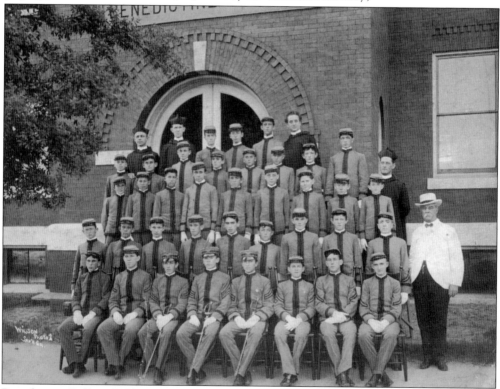

Benedictine College (BC) was started in 1902 as a boys-only school. The school has had three campuses. The first location is long forgotten, but the second location on Bull Street is still in use as Sacred Heart Academy. The present campus is on Seawright Drive. The entire student body of 1904 is shown here. (Courtesy Diocese of Savannah Archives.)

BC mothers have always been good about raising money for the school. One of the most profitable and enjoyable projects was the BC Bazaar and turkey dinner. Shown here is a group trying to win prizes at a bazaar in the 1950s. (Courtesy Diocese Savannah Archives.)

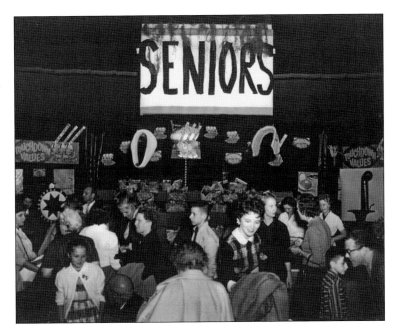

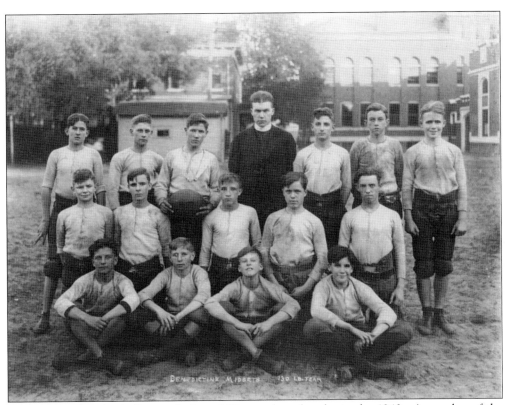

BC had a midget football team for boys 130 pounds and under in the 1940s. A member of the McGuire family is holding the football. (Courtesy Diocese of Savannah Archives.)

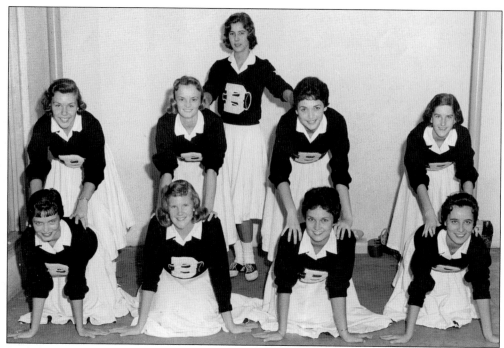

Since BC was an all-male school, their cheerleaders were chosen from St. Vincent's Academy, an all-female school. Pictured here from left to right is the 1959 cheering squad: (first row) Margie Dobson, Margie Rowell, Theresa Roughen, and Betty Ann Flynn; (second row) Mary Woodward, Sandra McAleer, Sheila Counihan, and Kaye Crump; (third row) Earline Williams. (Courtesy Counihan family.)

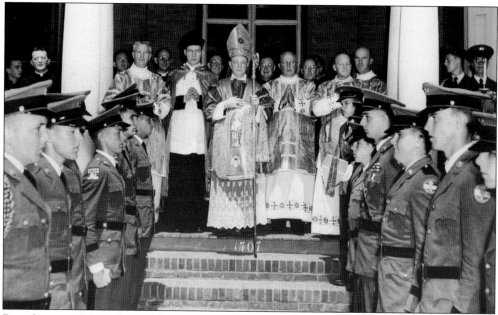

Benedictine celebrated its 50th anniversary in 1952. Pictured here are priests celebrating the occasion and being escorted by the cadet corps. The Benedictine Cadet Corps paraded in honor of the anniversary. (Courtesy Diocese of Savannah Archives.)

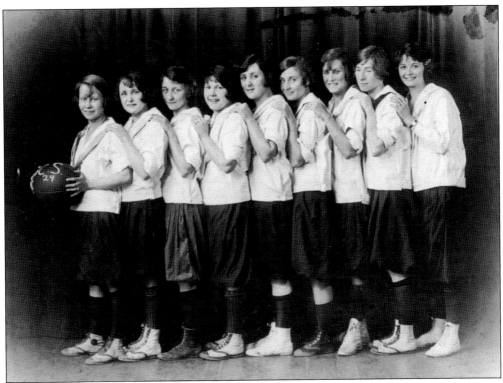

The various parishes had many different organizations for young people. Some were just for the parish, and others, like the Catholic Young People's Association (CYPA), were for the entire city. The Cathedral Sodality had a basketball team. Pictured here are the members of the 1924 team, from left to right: Angela Heffernan, Margaret Spellman (captain), Marie Sheehan, Mary Robider, Veronica McLaughlin, Julia McGouldrick, Catherine Cullum, Mary McGouldrick (coach), and Mercedes O'Driscoll (business manager). (Courtesy Diocese of Savannah Archives.)

Pictured here is a group of Sodality of Mary girls in the grotto area of St. Vincent's Academy. Sodalities were very popular; even adult women belong to the Sodality of Mary. (Courtesy Diocese of Savannah Archives.)

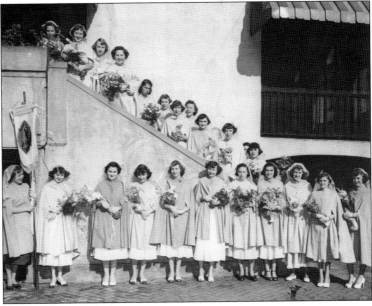

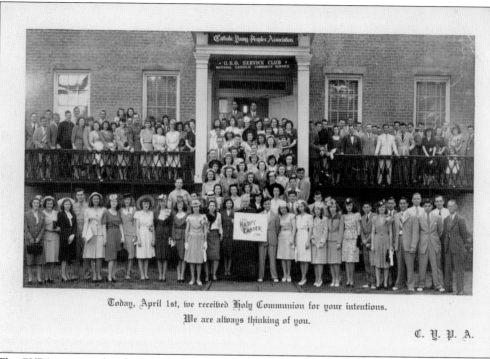

Today, April 1st, we received Holy Communion for your intentions.
We are always thinking of you.

C. Y. P. A.

The CYPA was at its height during World War II. It continued to be very active through the 1950s, and then various parishes started their own youth groups. Here, members send a pictorial card to former members in the service. This greeting really meant a great deal to servicemen; one of them saved his and donated it to the archives. (Courtesy Diocese of Savannah Archives.)

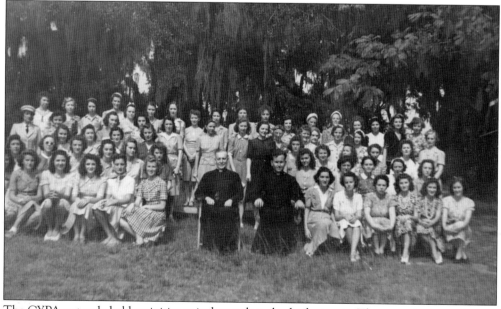

The CYPA not only held activities at its home, but also had retreats. The group is shown here at Camp Villa Marie in 1942. (Courtesy Diocese of Savannah Archives.)

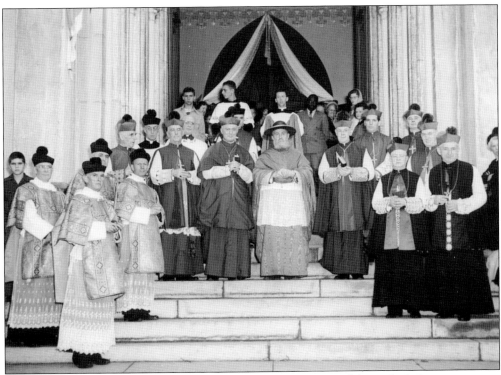

As you can see by the large gathering of clergymen on the steps of the cathedral, ceremony was very much a part of the life of the Irish Catholic. Pictured are, from left to right, (first row) Rev. Harold Barr, Rev. A.J. Gall, Bishop Emmet Walshi, Bishop Gerald P. O'Hara, Cardinal Tisserat, Bishop Hyland, and Abbot Vincent Taylor; (second row) Rev. Thomas Brennan, Rev. Norbert McGowan, unidentified, Rev. Daniel McCarthy, unidentified, Msgr. T.J. McNamara, Bishop Thomas McDonough, unidentified, and Vincent Ferraro. (Courtesy Diocese of Savannah Archives.)

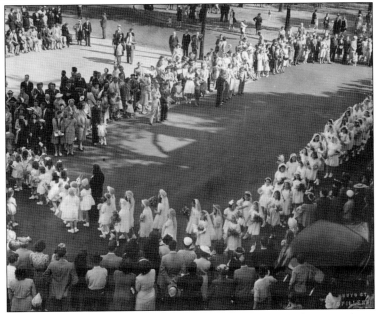

This concept of the church being part of daily life was definitely shown when children received First Communion. Here, a very large First Communion class can be seen processing into the cathedral. Often, everyone in the child's neighborhood came outside that day to celebrate. (Courtesy Diocese of Savannah Archives.)

Taking pictures with the family at First Communion was a big part of the celebration. Patty Gavin is the celebrant and is shown with her sisters, Peggy and Pete, and grandmother Gertrude Gavin on May 1, 1945. (Courtesy Pete Gavin DeBorde.)

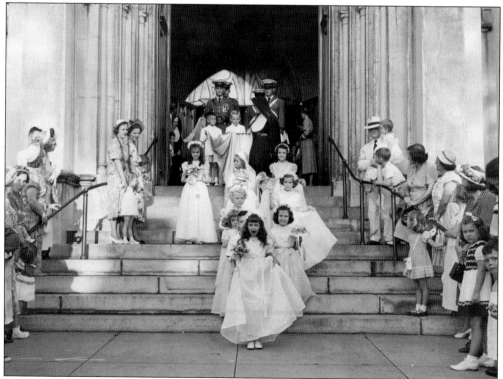

The First Communion, held in May, was a big event in each school. The Cathedral Day School has several clergymen, BC cadets, and lots of little girls in white dresses taking part in the procession in this image. (Courtesy Diocese of Savannah Archives.)

A very unhappy looking little boy carries a crown of flowers for Blessed Mother as the little girls happily march in a procession that includes altar boys. At least the boy's mother was happy. (Courtesy Diocese of Savannah Archives.)

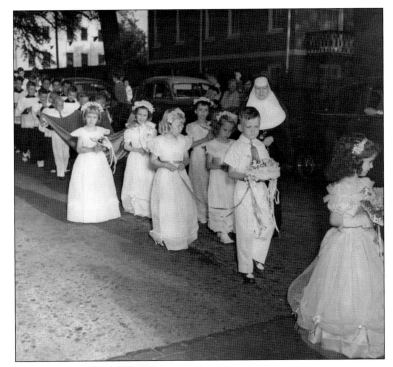

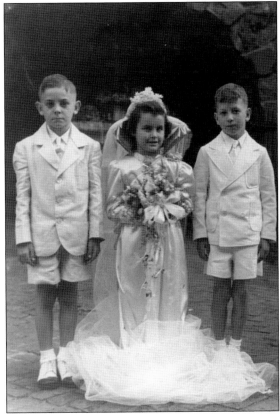

Anne Fasola makes a beautiful May Queen. She has two escorts and will crown Blessed Mother's statue with a crown of flowers. (Courtesy Diocese of Savannah Archives.)

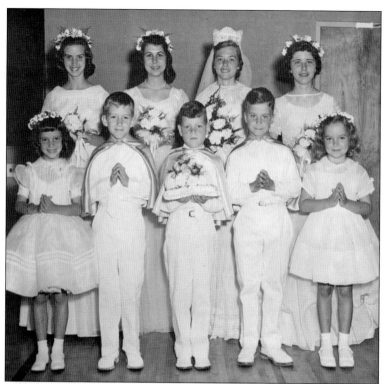

This May Procession group is from Blessed Sacrament. From left to right are (first row) Mary Byrnes, Harry Haslam, John Mulligan, George Rockwell and Nancy Hogan; (second row) Patricia Rockwell, Mary Frances Cook, Peter Daly, and Barbara Ann Purdy. (Courtesy Diocese of Savannah Archives.)

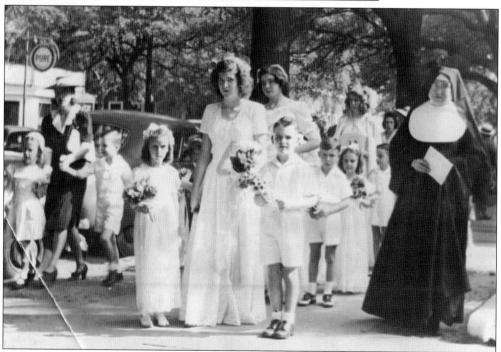

Patty Gavin leads a group of young students in the Sacred Heart May Procession as onlookers enjoy the sight. Often, St Vincent girls from the parish help with the May procession. (Courtesy Pete Gavin DeBorde.)

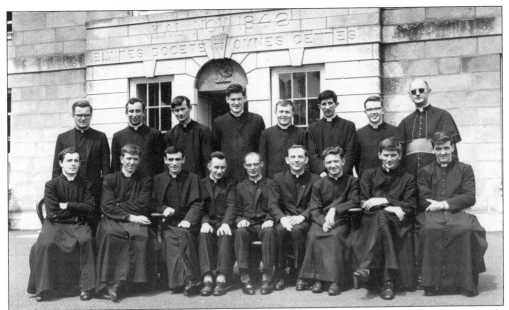

It would be impossible to list all the wonderful Irish men and women who came to Savannah to minister. Many of them were recruited by Monsignor Bourke for the Diocese of Georgia, something that the Irish in Savannah will be forever grateful for. While at seminary, these Irish priests were recruited by Monsignor Bourke. (Courtesy Diocese of Savannah Archives.)

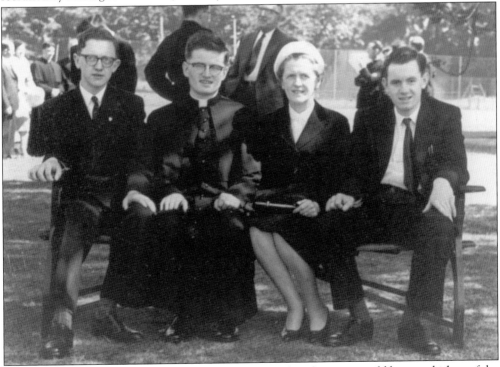

Little did the Boland family know on Ordination Day that their son would become bishop of the Diocese of Savannah. Additionally, he is now a US citizen. His brother has a wonderful shop, called Boland's, in Kinsale. (Courtesy Diocese of Savannah Archives.)

Msgr. T. James Costigan rode a bike as a child in Ireland and continues to do so as he leads the St. Peter the Apostle St. Patrick's Day celebration. Monsignor Costigan has served at St. Mary's on the Hill in Augusta and St. Michael's at Tybee. (Coutesy St. Peter the Apostle Church.)

The Irish nuns who came to Savannah would be proud to know that, for a time at least, many young girls followed in their footsteps. There have been many Savannah Irish nuns who joined various orders, but they join the Sisters of Mercy in particular. This picture of Sr. Mary Harper and Sr. Susan Harms was taken at Sister Susan's 50th jubilee. A good many of her St. Vincent's classmates came to Baltimore for the celebration, which shows one of the strengths of St. Vincent's Academy: SVA girls are friends for life. (Courtesy Harms family.)

# *Four*

# IRISH CHARACTERS

The Irish in Savannah are like a large family or clan (many families are related by blood as well as their love of Ireland). As in all large families, there are complex characters. You always know when someone is speaking of the dead because their name will be followed by "God rest his soul." When you hear someone mentioned followed by "God bless him," it usually means this is a character who probably needs that blessing in one way or another. "Bless his heart" usually means the person does good. However, It could also mean that the person is charmingly inept.

The really interesting characters (denoted with a "God bless and love them") are not included here for obvious reasons, but some of them will be briefly described. Come to Savannah, visit with the Irish for a while, and sooner or later the story will come out. One feisty young woman is written up in the paper in the early 1900s for being arrested several times for haranguing her neighbors. Then there was the gentleman who celebrated St. Patrick's Day to such an extent that his family and friends would make bets as to how far he would march in the parade. Another young man was a star runner for BC. He was chased by one of the priests, jumped out the school window, and ran home. He finished his high school career at Savannah High, where he ran against former teammates, often beating them. Then, there was the bar owner/finder of lost husbands. This particular gentleman owned the entire building where his bar was located. He was not Irish, but many of his customers were. Any man who overindulged could go upstairs and sleep it off, and the owner would send a messenger to the man's wife so she'd know where he was. He wouldn't go himself, as the long-suffering wife would often vent her anger on the messenger.

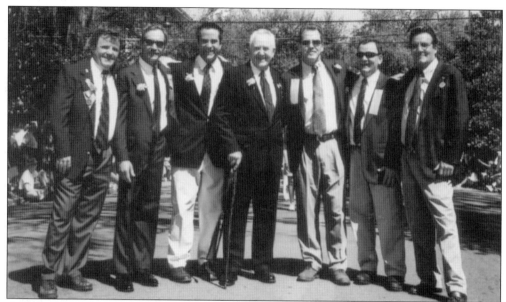

As Dan Sheehan, God rest his soul, said when he was invested as grand marshal, "The Irish like jollification." He is pictured here with his boys; sadly, Dan Jr. (far left) is now also deceased. Dan Sr. bought two pieces of the altar rail from Our Lady's Chapel in the cathedral at the Heritage Ball the year before he died and joked that they would be his and his wife Caroline's tombstones. Bless his heart, he never knew how soon that would happen. (Courtesy Savannah Parade Committee.)

Ron Winders and Raymond Fountain mingle at a grand marshal's election reception. For many years, Raymond drove the truck pulling the Daughters of Ireland float as his wife, Peggy, founded the organization. Gladys and Robby Brunson are in the background (Courtesy Savannah Parade Committee.)

Some of the biggest Irish supporters and contributors to the festivities are not Irish born. Rather, they have joined the shamrock tribe through marriage or just love of the Irish. Lucy Distephano (second from right) married Ted Haviland and became Mrs. St. Patrick's Day Tailgater. She has worked at both BC and SVA, and her hospitality to the priests, nuns, teachers, and any friendly person who wanders by is incredible. She parks that car loaded with food and is ready to singlehandedly end tailgater-hunger in Savannah, Georgia. Lucy is not just a fair-weather celebrator; she always has umbrellas and tents on hand to keep off rain. (Courtesy Ted Haviland.)

Laverne Burroughs McDevitt adds to the Irish festivities whenever she kicks up her heels in an Irish jig or helps Peggy Fountain and sidekick Jimmy Hogan with a picnic in the square on St. Patrick's Day. Pictured here from left to right are Pat Tuttle, Tommy and Gloria Brunson, and Laverne and Mike McDevitt at a 1950s party. Tommy was later elected grand marshal of the parade. (Courtesy Winders family.)

Joan Coon Mahany, wife of Joe Mahany (CPA, former county commissioner, and currently a gentleman farmer), has the perfect answer for each outlandish comment her husband makes: "Oh, Joe!" The Mahany clan's latest adventure is that they are part owners of an Irish racehorse. (Courtesy Savannah Parade Committee.)

Josephine "Josey" Clark Fahey met her husband, Tom, when they worked at the Central of Georgia Railway years ago. Each St. Patrick's Day, he would bring her and the children back to Savannah to enjoy the day as only a returning son of Savannah can. Like Joan Mahany, Josey has perfected the various tones of "Oh, Tom!" At least one of their sons always makes it back for the great day, even after all these years. (Courtesy Winders Family.)

Antoinette Matthews Ryan takes care of her family like the Italian grandmother she is. She insists that she isn't Irish, but she still keeps scrapbooks of the family, which includes three grand marshals, and attends everything Irish with her husband, Mike. She is pictured here at a picnic (which she packed) after the parade, surrounded by her favorite shamrocks, her children and grandchildren. (Courtesy Ryan family)

Linda Jaehne Winders is a great sport about all the Irish activities and has all three children ready to march each year. She and Kevin have a son, Ben, who will be marching with BC in 2014 as a freshman. Linda has been to parades that were cold, hot, wet, and wonderful through the years. The one constant is that she always has a smile on her face. (Courtesy Winders Family)

One of the most incredible Irish women of Savannah in the late 1800s was Margaret Elizabeth Smith Downing Rushing. Her husband, Denis Downing, died at 34, leaving her with four small children. She left her three daughters at St. Mary's Home for Girls and her son at Bethesda and enrolled in nursing school. She became a midwife and delivered most of her grandchildren and several of her great-grandchildren. She even delivered Bishop Andrew J. McDonald, who became bishop of Little Rock, Arkansas, after years of serving the Diocese of Savannah. (Courtesy Marie Greene.)

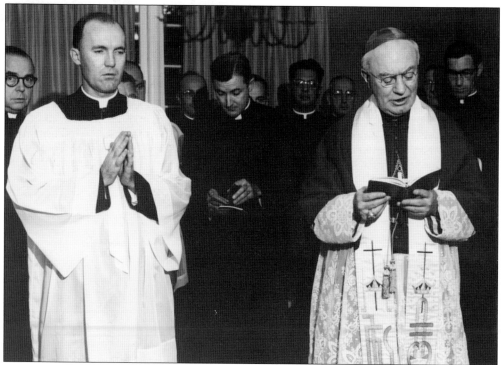

One of "Grannie's babies," Bishop Andrew McDonald, is shown with hands folded in prayer. In the picture from left to right are Msgr. McNamara, Reverend McDonald, Rev. Felix Donnelly, Fr. Bede Lightner, Fr. Norbert McGowan, and Archbishop Gerald O'Hara. Even after he was made bishop of Arkansas, Bishop McDonald made it a point to return to his Irish roots every St. Patrick's Day. (Courtesy Diocese of Savannah Archives.)

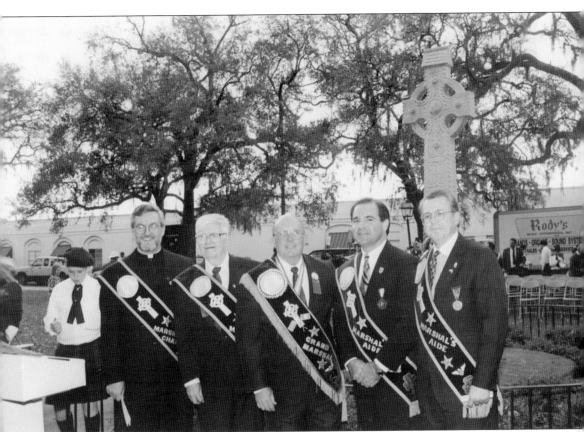

Joseph Ramsey retired from the Merchant Marine. He put his love of St. Patrick's Day and of BC into making lamps for the grand marshal of the parade each year and the many BC boys who excelled in one area or another. The Parade Committee named him Savannah's Ambassador for St. Patrick's Day. Jerry Hogan made him one of his aides. Standing in front of the Celtic Cross are, from left to right, Father Keneally, Joseph Ramsey, Jerry Hogan, Mike Beytagh, and Michael Halligan. (Courtesy Savannah Parade Committee.)

Frank Heffernan is pictured here at Camp Gordon in his Army uniform. His granddaughter, Carol Anthony, is a member of the Daughters of Ireland. (Courtesy Carol Anthony.)

From left to right, Michael Counihan, Bill Bray, Johnny DeBorde, and Garland Byrne seemed to have struck a deal at a Tybee City Council meeting. There are many Irishman in Savannah who practice the art of Irish diplomacy, which is telling someone to go to hell and having him look forward to the journey. (Courtesy Counihan family.)

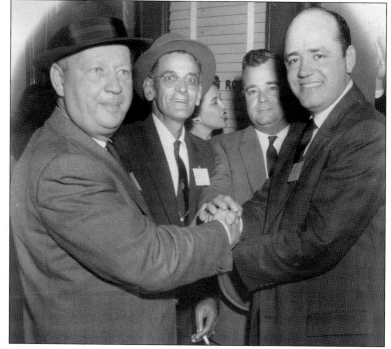

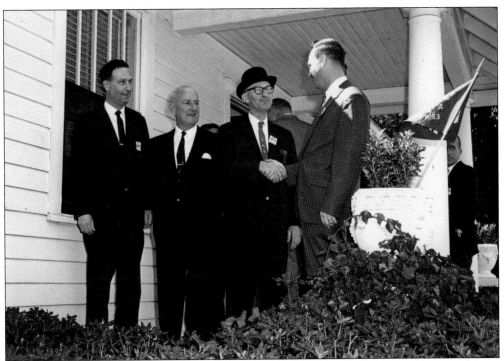

Here is another photograph in which some Irishmen are quite happy about an agreement. It's the handshake that seals the deal. (Courtesy Diocese of Savannah Archives.)

Are they celebrating St. Patrick's Day, life, or a super deal? All that is known for sure is that these are three happy men. (Courtesy Diocese of Savannah Archives.)

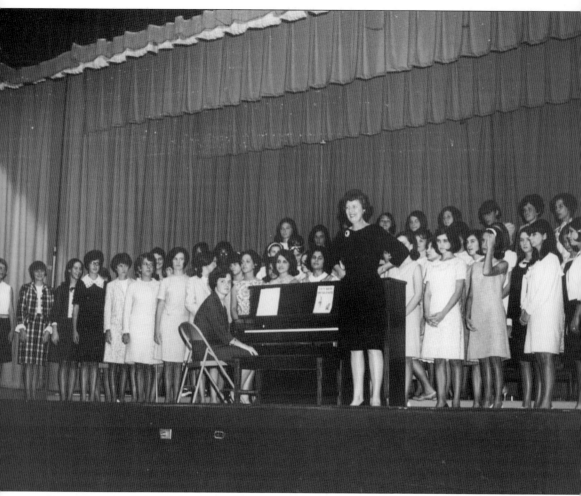

Patty Barragon Schreck has been the music muse of the Irish since she was a teenager. She has played the organ and directed the cathedral, St. Vincent's Academy, and St. Vincent's Alumna choirs and for years was the only lady in attendance at the Hibernian banquet. Her sister, Sr. Mary Fidelis, took the SVA Glee Club concerts to great heights during the 1950s. Patty is pictured here with the St. Vincent's Chorale. There have been male singers also. Joe Ebberwein led the SVA Irish Sing-Along for years. Harry O'Donohue also entertains when asked. Jim McLaughlin is the Irish tenor who sings at the Hibernian banquet. There are many more beautiful Irish voices that will lift in song at the drop of a shamrock. From Old Frog Town to the Old Fort, and don't forget old Yamacraw, they have always sung the praises of *Erin Go Bragh*. (Courtesy St. Vincent's Academy.)

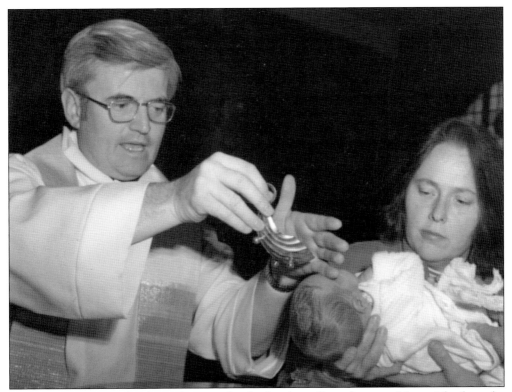

Rita Harper DeLorme has been the muse for the Southern Cross for years. Her articles from the Catholic Diocese Archives bring Irish history in Savannah back to life. Rita is shown here with Bishop Boland, who is baptizing her daughter. (Courtesy Diocese of Savannah Archives.)

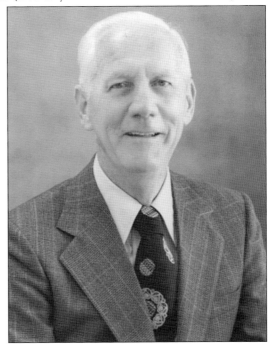

Of course, there should be an Irishman on the newspaper, as the Irish are in love with words. That man was Frank Rossitter Sr., who wrote "City Beat" for years before he went into politics. Because of him, Savannahians of a certain age always read the paper backwards because "City Beat" was on the last page but the first thing people wanted to read. It's said that Savannahians are like the Chinese because they read the paper backwards, eat lots of rice, and worship their ancestors. Frank was mayor pro-tem of Savannah, the 1972 grand marshal, and a past Hibernian president. His son, Frank Jr., has also held these two offices, leading the parade in 2008. (Courtesy Diocese of Savannah Archives.)

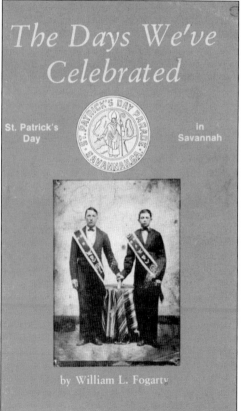

Probably the first book written about the St. Patrick's Day Parade in Savannah was Bill Fogarty's *The Days We've Celebrated*. In this book, he gives the history of the parade from its inception. (Both, courtesy Fogarty family.)

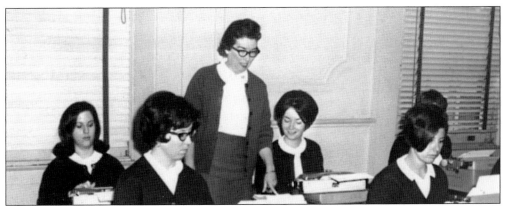

Margaret "Peg" Flannigan Dressel was an institution at St. Vincent's for over 30 years. Called the "last living Southern gentlewoman" by one of her student's fathers, she instilled a love of literature and a superior grasp of correct grammar in her students as well as an appreciation for a sharp wit. When Peg talked about the "Seven Deadlies," she wasn't worried about a student's soul but, rather, her grammar skills. (Courtesy St. Vincent's Academy.)

Sr. Mary Jude Walsh has been a fixture at St. Vincent's for more years than she can remember. Prior to that, she served at St. Mary's Home and in grammar schools. She has been called a Renaissance woman, as she can do just about anything required at the school. She is retired now but, in between crabbing at the beach, she can be found working in the SVA archives. (Courtesy St. Vincent's Academy.)

Bridget "Bridgie" Fogarty was an SVA graduate and basketball coach who devoted herself to the school. An admirer donated a school bus to SVA in her name, and girls frequently enjoyed trips on the "Bridgie Bus." (Courtesy Gavin Family.)

Eddie Beranc was a man who could be seen all over Savannah from the 1940s to the 1960s. He attended Mass several times a day and always had his rosary with him. If there ever was a man to inspire devotion, it was Eddie, who is shown here by the statue of St. Patrick in the cathedral. (Courtesy Savannah Parade Committee.)

Bill Harris Jr. is not only a doctor, but also a fine writer. His novels always incorporate Savannah happenings and characters. His works include *Delerium of the Brave*, *No Enemy but Time*, and *Warsaw Sound*. Bill's father was a former Chatham County sheriff. He is shown here with Bishop Boland. Bill was one of Monsignor Bourke's aides the year he was grand marshal. (Courtesy Parade Committee.)

Sports are a big part of the Irish lifestyle. Maurice "Mutt" Sheppard wrote a book about the annual Savannah High and Benedictine football rivalry, which began in 1903. The game used to be held on Thanksgiving afternoon and, while the teams still play each other, the rivalry effectively ended on the last Thanksgiving day game, held in 1959. (Courtesy Maurice Sheppard.)

Paul Camp has been recording the parade and other Irish events since 2009. Prior to his work, pictures of the Irish activities were hit or miss. (Courtesy Paul Camp.)

# *Five*

# IRISH SOCIETIES AND ORGANIZATIONS

The spirit of fun and fellowship (jollification) is exemplified in the various Irish organizations. The Hibernian Society is the oldest and most steeped in tradition. It was founded in 1812.

There were many Irish societies formed in the 1800s, but few of them survive today. Some societies that live only in memory are the Fencibles, a defense force that held the 1818 St. Patrick's Day Parade; the Irish Union Society, which held the 1847 parade; and the Savannah Catholic Temperance Society, which marched only once in the parade in 1841.

The Celtic Cross monument was erected as part of the 250th birthday celebration of the state of Georgia. The committee decided on the cross, a common sight in Ireland, because Irish contributions to Georgia are so numerous that it would be unfair to choose just one. Savannah Irish all have a share in the cross; they all have an Irish success story and Irish ancestors that they think of when they look at it. The materials themselves, the cross carved out of Irish limestone from County Roscommon and the base made of Savannah grey brick, are symbolic. The feet of the Savannah Irish, represented by the base, are in Georgia, but they still have the Irish aura about them.

When the Celtic Cross monument was dedicated in Emmett Park on December 3, 1983, discussion began about holding a Celtic Cross ceremony each year. The first ceremony, which began with Mass in the cathedral followed by a program at the cross site in Emmet Park, was held in 1986. It is usually the Sunday before St. Patrick's Day. Each original member of the Celtic Cross committee has spoken at the event. Each organization places its banner around the cross prior to the ceremony. The Celtic Cross Ceremony is hosted by all the Irish societies, which march into the cathedral in order of their founding. There is, of course, a reception afterwards.

There are also two festivals during the season of St. Patrick. The Savannah Irish Festival, which features entertainment stages as well as vendors selling food and things Irish, is held at the beginning of the season in mid-February. Tara Feis is a festival held in the area of the Celtic Cross in Emmett Park and is an all-day festival with emphasis on family. There are many children's activities, including Irish dancing and hands-on activities, as well as performance stages. It is a beautiful outdoor festival.

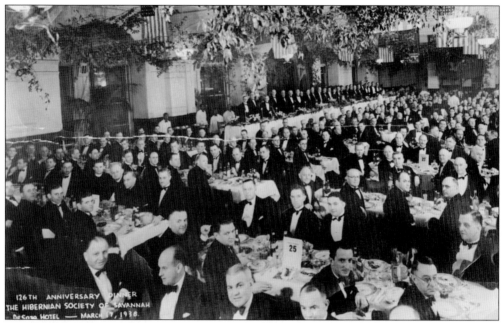

The Hibernians have quarterly dinner meetings as well as a luncheon and banquet on St. Patrick's Day. Of all the Irish societies, they are the most elegant. The food and camaraderie are much the same today as in the pictured banquet from 1934. (Courtesy Jack Jaugstetter.)

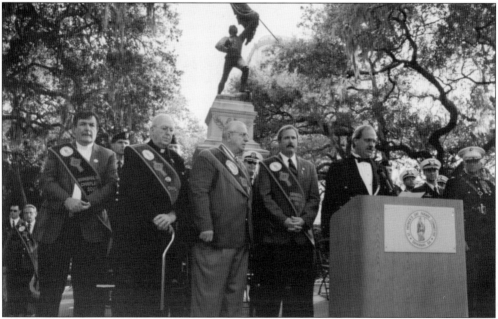

The Irish Jasper Greens were founded in 1842. They were a militia company that honored Sgt. William Jasper, a local hero of the American Revolution. The uniform was green in his memory, with buttons in the shape of a harp to symbolize Ireland. Each year on the eve of St. Patrick's Day, a celebration is held at the Sergeant Jasper monument in Madison Square to honor the military. Pictured here from left to right are Fr. Patrick O'Brien, Fr. Joseph Ware, Eddie Fahey, Gary Ogden, and Sonny Dixon. (Courtesy Paul Camp.)

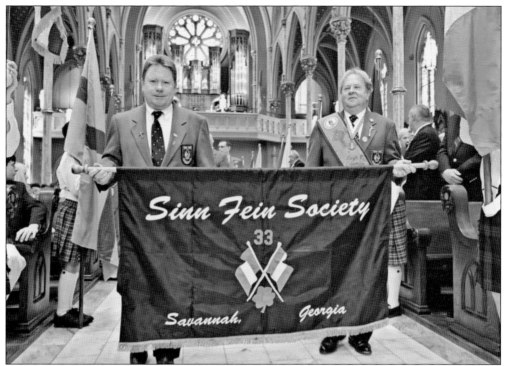

The Sinn Fein society was organized in 1965. The group began the tradition of an early morning breakfast, with green grits as the centerpiece, accompanied by the "morning dew" (Irish whiskey). Eddie Fahey will always be remembered as the president who set the grits on fire. (Courtesy Paul Camp.)

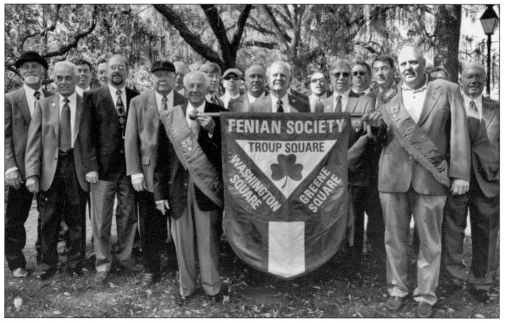

The Fenian Society was founded in 1973 and is open to former residents of the Old Fort area, Troup, Washington, and Greene Squares in particular. Ask any of the older members about "hooking boxes" for the various squares' New Year's Eve bonfires. (Courtesy Paul Camp.)

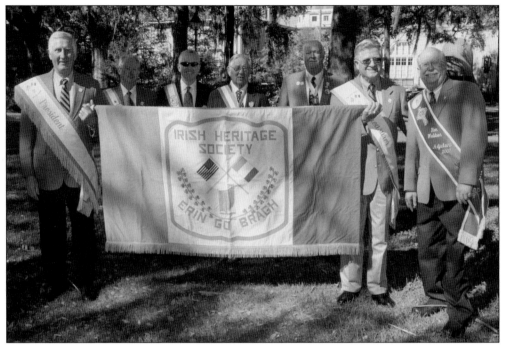

The Irish Heritage Society was founded in 1974. It sponsors a dance before St. Patrick's Day and hosts a reception after the parade. Tickets to this reception are highly sought-after, as it is held close to the parade's end at the Civic Center. (Courtesy Paul Camp.)

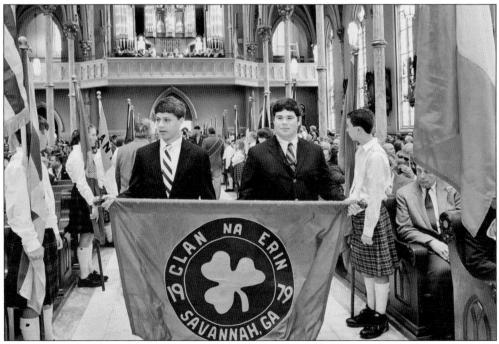

Clan Na Erin was founded in 1979 and hosts an early morning St. Patrick's Day breakfast at the Oglethorpe Club. It is infamous for the fines levied at this breakfast, but they go to a good cause, typically to a charity such as the Wounded Warrior Fund. (Courtesy Paul Camp.)

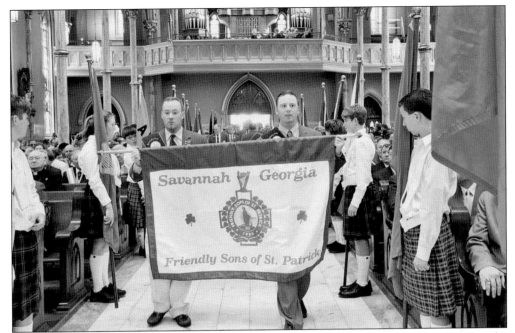

The Society of the Friendly Sons of St. Patrick holds a dinner in the weeks prior to St. Patrick's Day. Mary Harper, however, will always remember St. Patrick's Day 2005 as one of the Friendly Sons' finest hours. Walt Harper proposed to Mary in front of the Friendly Sons on the steps of the cathedral that morning. (Courtesy Paul Camp.)

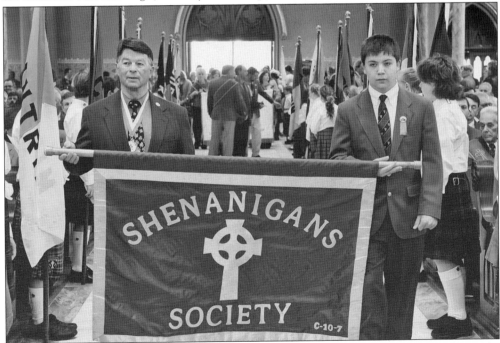

The Shenanigans Society was founded by the late Harry Deal. Its purpose is fun, as is obvious by its "high leprechaun," who leads the group in telling jokes and providing "jollification." (Courtesy Paul Camp.)

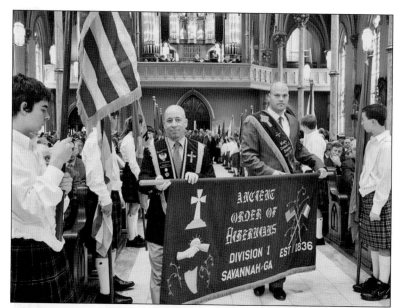

The Ancient Order of Hibernians (AOH) reorganized in the early 1980s. Its main focus is working with the Savannah Irish Festival, which is held in February and is one of the first events in the season of St. Patrick. (Courtesy Paul Camp.)

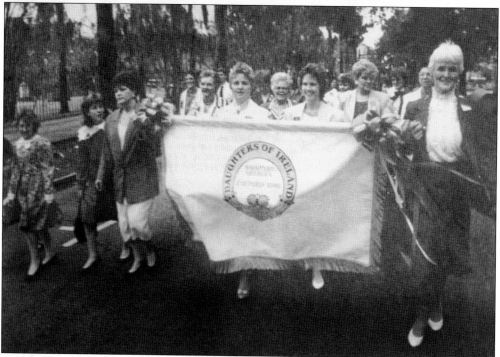

The Daughters of Ireland was established in 1986 by Peggy Gavin Fountain and some friends after the first Celtic Cross ceremony in March 1986. The response was overwhelming. The group holds a major fundraiser, the Half Way to St. Patrick's Day Party, each year. They also volunteer at the Savannah Irish Festival and at the K of C Oyster Roast and host a party for the grand marshal's wife, who is presented her own sash. They hold a brunch the morning of the grand marshal's election and eagerly await the phone call announcing the winner, who is often the husband of a member. In this 1987 *Savannah Morning News* photograph, Peggy Fountain is on the right, holding the banner. (Courtesy Daughters of Ireland.)

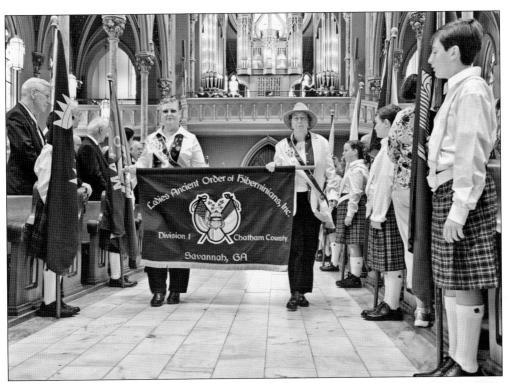

The Ladies Ancient Order of Hibernians works in conjunction with the AOH. Their main focus is also the Savannah Irish Festival. They have very loyal husbands. Because the Irish organizations process into the cathedral for the Celtic Cross Ceremony Mass in order of their founding, the two groups are separated. Their husbands graciously moved to the Ladies AOH spot to walk with them. Perhaps this is because of the saying, "Living with an Irish woman builds character." (Courtesy Paul Camp.)

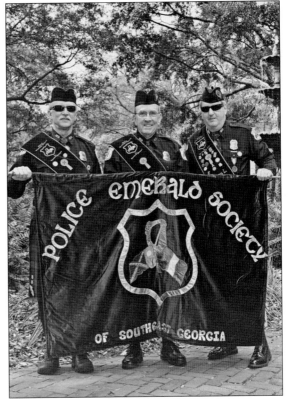

The Police Emerald Society of Southeast Georgia was founded in 1998. Nick Kenny and other policemen who can trace their Irish and police roots back several generations were the founders. (Courtesy Paul Camp.)

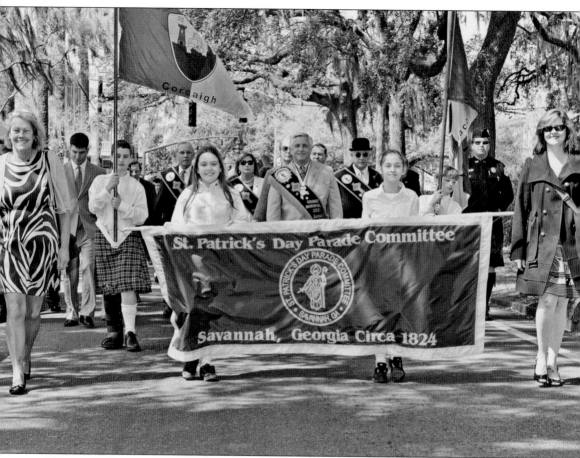

There are other organizations as well. The St. Patrick's Day Parade Committee has hundreds of members and is the organization that elects the grand marshal. One must attend a minimum of three meetings a year for two years in order to be eligible to vote. (Courtesy Paul Camp.)

## Six

# THE IRISH ON
# ST. PATRICK'S DAY

There is some discussion about exactly when the first St. Patrick's Day Parade was held in Savannah. This is not surprising, as the number of opinions in an Irish discussion depends directly on the number of people discussing the matter. However, the Parade Committee designated 2013 as the 189th parade and, since there are few photographs of early parades, that seems to be a good number. That 189th parade would have astonished our Irish ancestors, as it is a far cry from the smaller marches held originally. Through the years, many aspects of the parade have changed, but not the purpose, which is to honor St. Patrick and express to the world an Irishman's pride in heritage.

While the parade was 189 years old as of 2013, the Parade Committee in its present organized form is not. In the early years, the organization was more casual, with the very first parade sponsored by the Hibernians being a private affair. In 1948, Michael Finney and Henry James served as the first parade marshals. The inception of the Grand Marshal of the St. Patrick's Day Parade in Savannah came about in 1870. There were several organizations that participated in the parade, and each had its own marshal. These marshals formed a committee that acted on behalf of their respective organizations; the chairman of the committee was called grand marshal. John Feely of the Hibernians was the first grand marshal.

In the 1940s and 1950s, parochial school children from fourth to eighth grade all marched in the parade along with the schools' boy scouts, cub scouts, brownies, and girl scouts. The parade is too large for that now; instead, there is a float representing catholic schools in Savannah. One thing that has not changed is that Benedictine Military School always marches and that St. Vincent's girls (and others) thrill to see them. Some young ladies take delight in giving unsuspecting cadets a kiss on the cheek, the girls leaving their mark with bright red lipstick.

The first third of the parade is composed of Irish organizations and Irish families, along with marching bands. A visitor to Savannah said that the parade would be much more manageable without "all those Irish people walking in it." She was quickly informed that "those Irish people" are the heart and soul of the parade. The rest is just window dressing. The clothes and the weather may change each year, but the Irish spirit shines forth throughout.

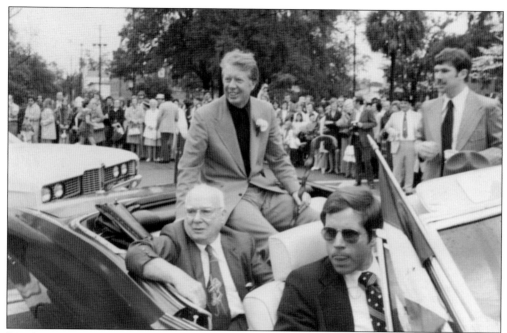

Pres. Jimmy Carter has been in the parade twice, once as president and once before he was elected. This picture shows him riding in his pre-presidential days. On this occasion, he visited the patrons of Pinky Masters and stood up on a stool to explain why he should be elected. (Courtesy Diocese of Savannah.)

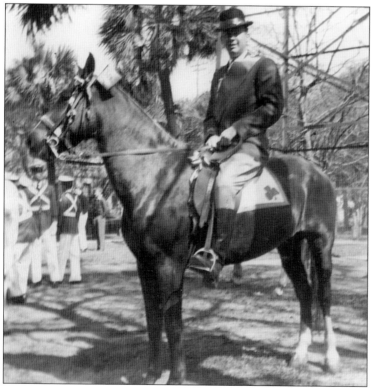

William "Billy" T. Summerlin is ready to ride in 1949 as BC cadets wait to march. Horses have been a popular part of the parade for years. (Courtesy Cecilia Courtney.)

The Marist Drum and Bugle Corps is seen here around 1933. The Cathedral Day School continued this tradition even after Marist closed. From left to right are (first row) Louis Richardson, M.A. Spellman, Charles Courteney, Jack Maher, Nick Kenney, ? Brennan, Donald Richardson, and Harvey James; (second row) ? Mendel, unidentified, Billy Coyle, V.J. Romagosa, John Power, Joseph Craig, Joseph Teston, and two unidentified. (Courtesy Cecilia Courtney.)

From left to right, Marie Fahey, Anne Fahey Counihan, Lillian "Lila" Fahey Clark, Mary Jane Fahey Brown, and Joe Counihan await the parade around 1965. Parade viewing and people watching are great around the cathedral, and many people congregate there and then move on to the end of the parade once the Irish pass by. (Courtesy Brown family.)

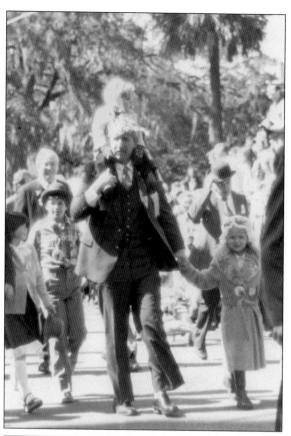

Children love to be in the parade, and "Uncle Joe" Counihan obligingly marched with Joe and Shelley Carroll. Or, more accurately, he marched and they took turns being carried. (Courtesy Carroll Family.)

Dogs are often seen in the parade as well. Bill Carroll is seen here as he walks with Josh and Shelley Lowther and their furry friends. (Courtesy Carroll Family.)

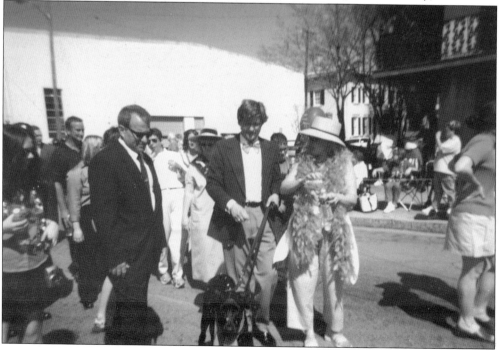

John J. Leonard, chief of the Savannah Fire Department, was grand marshal in 1975. Several police officers have also been elected grand marshal. (Courtesy JoAnn Leonard Aulwes.)

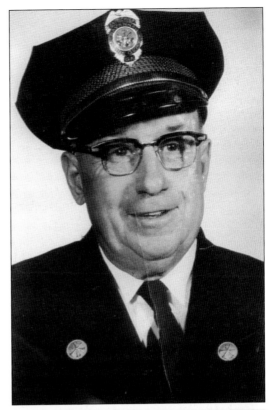

From left to right, Toby Buttimer, Grand Marshal John Leonard, John Leonard Jr., Dennis Leonard, and John Rousakis are at a parade banquet in 1975. The grand marshal's schedule is time consuming between election and the parade, usually involving a minimum of two events per day. (Courtesy JoAnn Leonard Aulwes.)

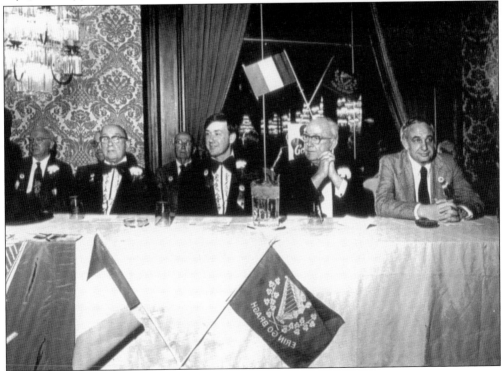

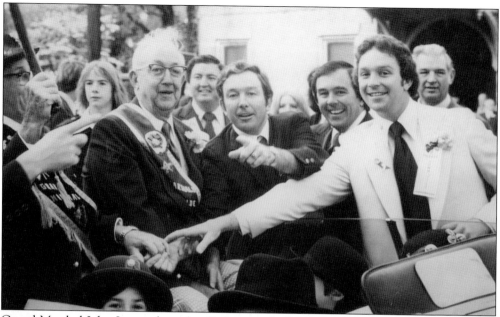

Grand Marshal John Leonard can hardly be seen for his derby hat and shillelagh. His aides, relatives, and friends, however, are having a good time. From left to right, Denny Leonard (who helped found the St. Patrick's Day Parade in Augusta, Georgia), Denny Herb (a later grand marshal of the parade), Leonard Herb, Joe Herb, and Robbie McGrath can be seen around the car. The prettiest one in the car (Michelle Phillips Gant, John's first grandchild) can hardly be seen. (Courtesy JoAnn Leonard Aulwes.)

Since the derby is popular with Irishmen in the parade, it has, of course, caught on with ladies also. Anne Fahey Counihan wanted one so much that her parents gave her one for Christmas, which she wears proudly in this image as she and niece Shelley watch the parade. (Courtesy Carroll Family.)

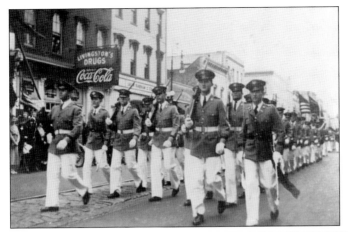

Benedictine Cadets have consistently marched in the parade since 1903. Michael Counihan is one of the cadets marching in this c. 1934 image. (Courtesy Counihan family.)

Generations of young men have attended BC. Here, two cousins are ready for their first parade as BC cadets: Jerry (left) and Joe Counihan (right). Young Dennis watches and waits for his turn. (Courtesy Counihan family.)

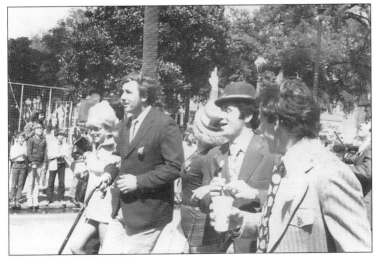

Even after they graduate, BC boys like to walk in the parade, as walking is much more fun than marching. From left to right, cousins Joe and Jerry Counihan, along with cousin Dennis Kelly, walk in the parade. (Courtesy Jerry Counihan.)

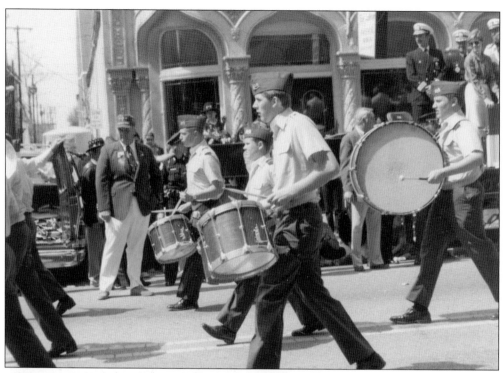

The BC band is not as large as other marching bands as it is a small military band, but they are cheered as loudly as any others. Ron Winders Jr. (foreground) liked the band so much that he played all four years he was at BC, even though he wasn't in ROTC the last two years! The band has just passed the grand marshal's reviewing stand. Saints and Shamrocks, a great Irish shop, is in the background, and Larry Loncon is standing by the car, giving trophies to various units in the parade. (Courtesy Winders family.)

It is almost as big an honor for a BC cadet to lead the BC brigade as it is for the grand marshal to lead the entire parade. Kevin Winders, cadet commander, led the cadets in the 1979 parade. This honor runs in the family, as Kevin's cousin, Dr. Hal Brown, was also cadet commander. (Courtesy Winders family.)

Robby Brunson, whose son, Tommy, was later grand marshal, is aide to Grand Marshal Leo Ryan (left) along with Bill Foran, who became grand marshal in 1983. The driver is George Backus of Backus Cadillac/Pontiac. The day of Leo's election it was snowing, a rarity in Savannah. Leo made the comment that many people said it would be a cold day in hell when he was elected. (Courtesy Antoinette Ryan.)

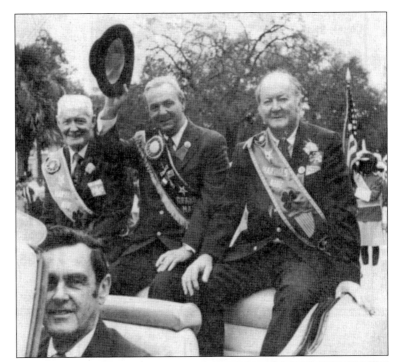

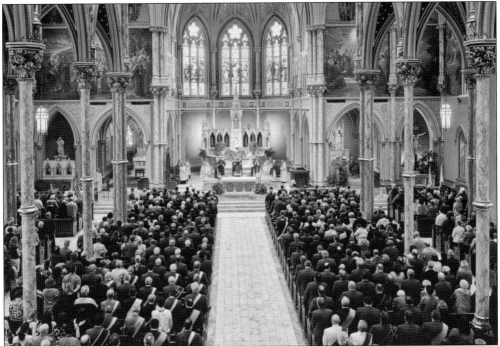

There are few churches as beautiful as the Cathedral of St. John the Baptist on St. Patrick's Day morning, when the church is decorated with green shamrocks and filled with Irish worshipers. The grand marshal enters the church with his aides and family prior to the beginning of Mass. For many years, WTOC TV has aired this beautiful ceremony prior to airing the entire parade. (Courtesy Paul Camp.)

Two cousins, Michael and Sheila Counihan, await the parade in this photograph. Sheila is looking warily at the crutches that Michael is wielding like a shillelagh. Like many Irish families, they lived on the same block in downtown Savannah along with various other Irish families. On one block of Hall Street alone there were four houses with Counihan or Fahey families. (Courtesy Counihan family.)

Clan na Erin, established in 1979, encourages its members to march with their families, which their children really enjoy. One of the great parts of the parade is seeing whole families celebrate together. Sometimes this is difficult, as Dad or Mom may belong to more than one organization. (Courtesy Parade Committee.)

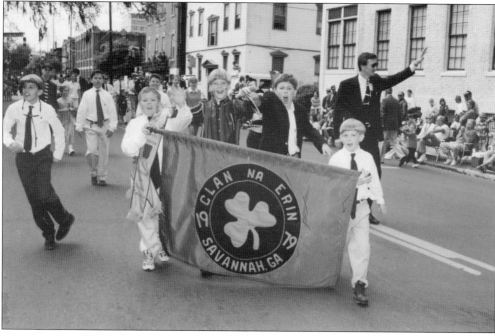

The Daughters of Ireland have always had a float that older members and younger children can ride. Other members walk along with the float. The Daughters always make sure their Irish Queens (members who are 80 and above) get special treatment if they want to ride. (Both, courtesy Daughters of Ireland)

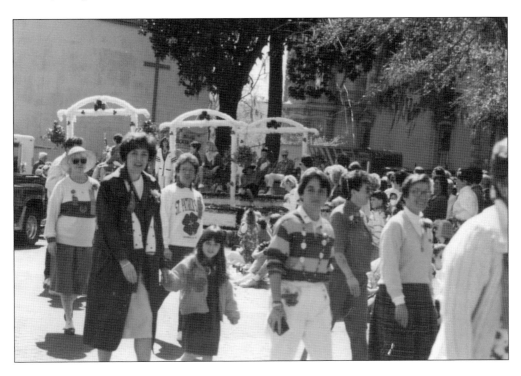

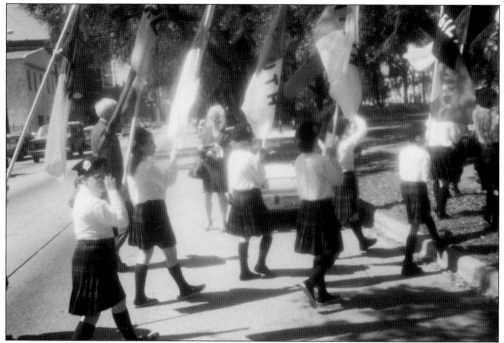

Some wonderful parents formed the Irish Flags unit, in which each child carries one of the flags of Ireland. The parents who have worked with this unit through the years are as dedicated as the children because the unit is in demand for much of the season of St. Patrick. (Courtesy Carroll Family.)

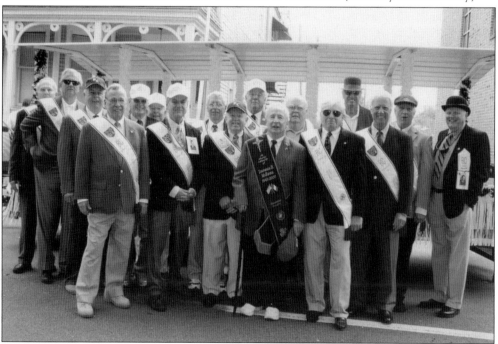

Many groups march in the parade, but the BC Class of 1959 goes all out. Some years they march, some years they have a float. BC boys tend to stick together, but this is an unusual class in that the members attend funerals of classmates as a group and hold a reception for the family afterwards.

Mickey Dooley was a policeman beloved by neighborhood boys in the Old Fort area. He shared the grand marshal title in 1961 with Eugene Butler. This was the year they tried to dye the Savannah River green. (Courtesy *Savannah News Press*.)

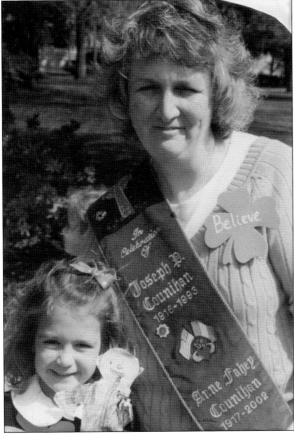

Many of the Irish, both men and women, wear memorial sashes and march in celebration of those no longer here. Deborah Carroll, kindergarten teacher at Blessed Sacrament School, wears hers to the Greening of the Fountain in Forsyth Park, where she brings her class each year. (Courtesy Carroll Family.)

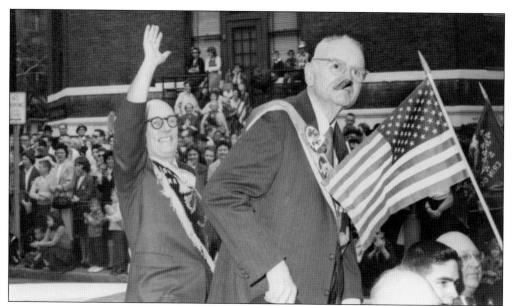

Grand Marshal Charles Powers enjoys a cigar while his aide, Joe McDonough, waves to the crowd. Barely visible in the middle of the front seat is Mike McDonough, Joe's son. (Courtesy Diocese of Savannah Archives.)

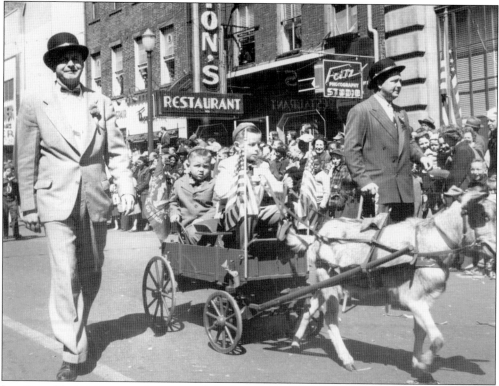

Leo Ryan liked doing something special for the parade, so he had a goat cart made for his sons, Mike and Tony, to ride in. All three Ryans became grand marshal of the parade in later years and got to ride in the front car. (Courtesy Antoinette Ryan.)

Before the goat came the horse and buggy for Leo, Mike, and Tony Ryan (above). Mike and Tony must have liked this transportation best because years later, they got a horse and buggy for their own children to ride in the parade (below). (Courtesy Antoinette Ryan.)

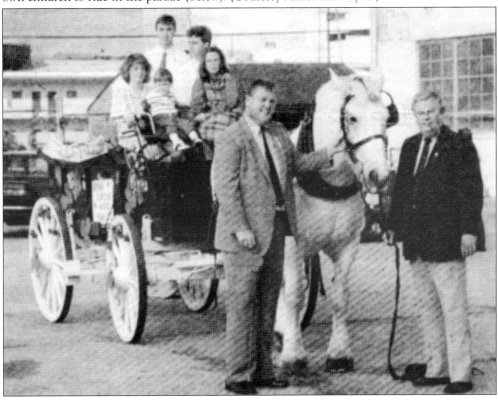

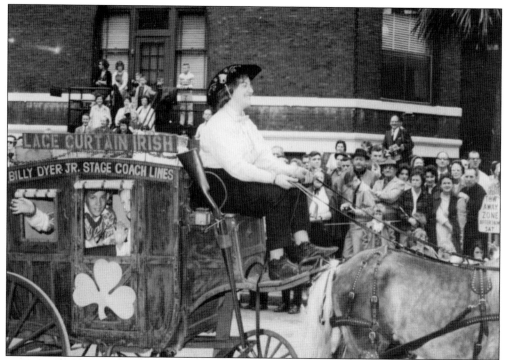

Many Irish families enter floats in the parade. The Dyer family decided to use a stagecoach pulled by horse for his one. (Courtesy Diocese of Savannah Archives.)

This group, Erin's Best, has a cart pulled by Ron Winders Jr. on a motorcycle. Tommy Brunson arranged this float for many years; his son, as well as many other children, enjoyed riding it in the parade. (Courtesy Parade Committee.)

The steps of the cathedral are a popular place to watch the parade as it is situated at the very beginning of the route. From left to right, Bishop Lesard, Monsignor McNamara, and Fr. Larry Lucree enjoy a prime spot for parade watching. (Courtesy Diocese of Savannah Archives.)

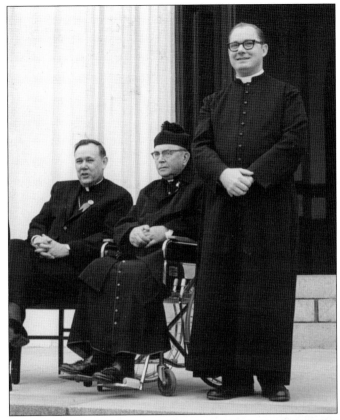

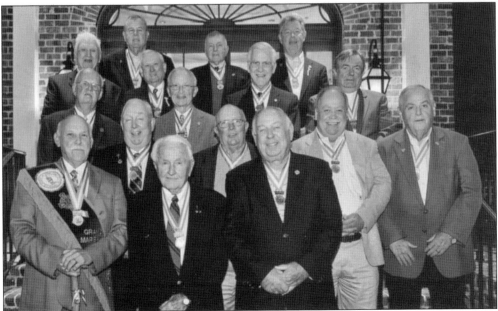

The faces of these past grand marshals appear in many "worker bee" images taken throughout the season of St. Patrick. That is because the man chosen to be the grand marshal has usually worked tirelessly for the parade in one way or another. (Courtesy Savannah Parade Committee.)

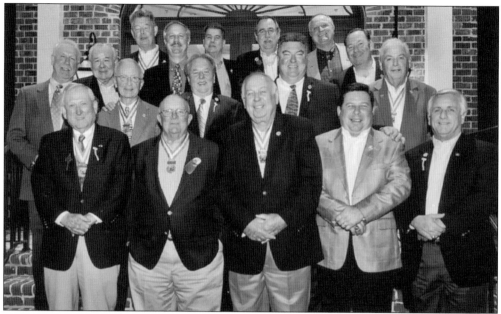

In 1926, the St. Patrick's Day Parade Committee was formed and the first adjutant in 1927 was Daniel J. Sheehan. In 1947, the Office of Parade Committee Chairman was established and Robert F. Downing became the first chairman. The chairman and adjutant, along with the adjutant's staff, are volunteer workers who dedicate their time year round to make the parade the success it is. The Parade Committee is the first unit in the parade after the grand marshal. (Courtesy Savannah Parade Committee.)

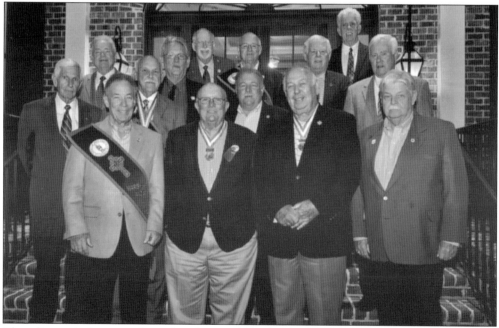

The adjutant is the man who makes the parade work; he and his staff work tirelessly before and during the parade. They are the men in the white coats and are the last unit in the parade. On March 18 of every year, these men begin preparations for the next parade. If you like the parade, thank a man in a white coat. Pictured here are past adjutants. (Courtesy Savannah Parade Committee.)

# Seven

# IRISH PLACES AND FACES

Like the people, many buildings important to the Irish are now physically gone but live on in memory. Some, fortunately, are still here for us to enjoy. Many Irish remember the neighborhood fire station fondly as a place they hung out. Two men, Ted Haviland and Julian McKenzie, thought the men of Station No. 1 and No. 9 should be honored and, on their own initiative and with help from Ellen Harris, a commission preservation planner, erected a marker in Washington Square. Station No. 9 in the square safeguarded the Old Fort from 1847 to 1875. The volunteer company was composed of Irish immigrants and men of Irish descent, all of whom wore leather helmets and red-flannel shirts with green braid. No. 9 won awards for its skill in competitions, but what really set it apart was its location in Washington Square with a cistern nearby for water supply. When the city went to paid fire departments, the station was demolished and Station No. 1 on Broughton Street took its place in the hearts of the Irish community. The men painted a shamrock over their main door and each St. Patrick's Day the company would stretch a huge Irish flag across the street. The cornerstone of the building was inscribed with, "Washington Fire Co. 1847–1875."

Many Irishmen went to work for the police and fire departments. This may have been standard procedure prior to the late 1930s, but two very popular religious figures made the practice of interest to many. Because there were so many Irish (read: Catholic) men wanting to join the various forces, it became the unwritten practice for one job to go to a Catholic and the next to a "Cracker" (a term used for Protestants of South Georgia). The "go-to" man for the Crackers was the Rev. John Wilder of Calvary Baptist Temple, known as Brother Wilder. For the Irish Catholic, it was Msgr. T. James McNamara (Monsignor Mac). This practice continued until African Americans were able to join the police and fire departments and then, it is said, the jobs were rotated between the "Cracker, Irish, and black."

The firemen were part of the neighborhood and were many young boys' role models and friends. They fixed toys, repaired appliances, and arbitrated disputes between husbands and wives. For Ted Haviland, one of them, Capt. Arthur Watson (left), became a surrogate father when his own father was killed in World War II. Years later, the two are still friends and, as can be seen from what Ted is holding; Captain Watson is still bringing him toys. (Courtesy Ted Haviland.)

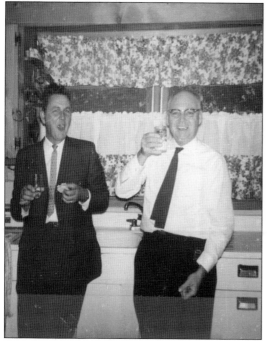

In Ireland, they used to call it a *ceili*; in Savannah, they just call it a party, but it is all the same. Pictured throughout this book are a variety of parties; the theme may be different, but all are having a wonderful time. Lawrence Fillyaw (left) and Joe Counihan are sharing a joke and a toast in the kitchen at Joe's daughter's wedding reception. He is probably toasting the fact that they now use her bedroom as a den. (Courtesy Counihan family.)

It wouldn't be surprising if Monsignor McNamara (seated in wheelchair) was making a deal for jobs in this photograph. He was always thinking of his congregation and working with city and county officials to find jobs for those who needed one. (Courtesy Diocese of Savannah Archives.)

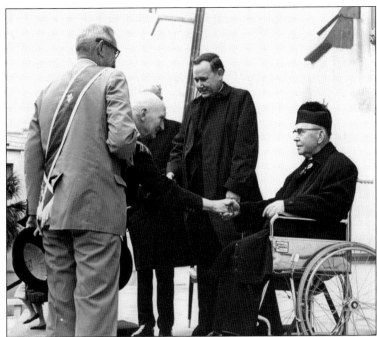

The Irish love to hunt, as shown in this photograph of proud hunters and their trophies, which will keep many Irish stomachs happy. Hopefully they didn't do like their ancestors often did and poach on someone's land. (Courtesy Jack Jaugstetter.)

Parties for the grand marshal are continuous from his election in mid-February until March 17. Here, the entire Leonard family pauses for a picture at a formal event. (Courtesy Leonard family.)

Of course, there are more lively partiers. Here, Jerry Counihan (left) and Richard Strickland celebrate St. Patrick, Ireland, and life in general. (Courtesy Jerry Counihan.)

Gildea's on Victory Drive is no longer. It was a popular gathering place and even had a drive-in movie in the back. It's boy's night out in this picture. From left to right are (first row) Tommy Davis, George Moore, Jerry Ware, Dick Welsh and Willie Girareau; (second row) "Goat" Oliver; (third row) Walter Richter, M.A. Spellman, Barrett Welsh, Billy Price, Dick McDonald, Buddy Fisher, Red Fogarty, Jimmy Gleason, Joe Canty, and Buddy Murphy.

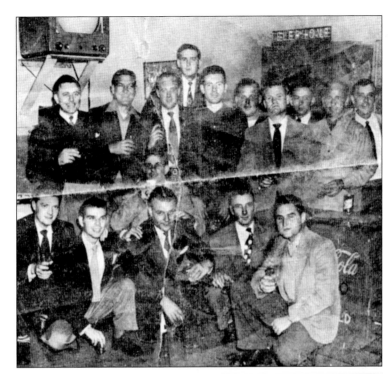

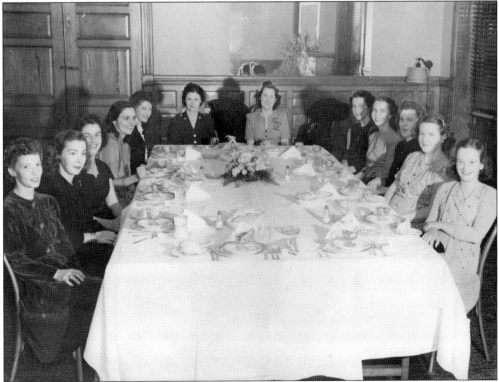

Bridal luncheons were popular in the 1940s. This group of ladies is feting Mary Jane Fahey (center right), who is engaged to Henry Brown. (Courtesy Brown family.)

The Catholic Cemetery is a treasure trove of Irish history. The Catholic Cemetery Preservation Society was formed to make sure that this treasure remains intact. Joe Counihan, dubbed the "Cemeterian" by Bishop Boland because of the work he does in the cemetery, has served as president of the organization, which has compiled books listing the locations and names of all the graves. Joe's father (Joseph Patrick Counihan Sr.) took him for walks there often. Joseph Sr.'s father died when he was two and his mother died right before he got married. On Joseph Sr. and Anna Fahey's wedding day, they went to the cemetery and she left her bridal bouquet there on her new mother-in-law's grave. Joe absorbed all his father's stories about family members and friends buried there and works hard to keep the cemetery a viable treasure. (Courtesy Diocese of Savannah Archives.)

The Irish children in Savannah always have a look of Erin about them. These two images should be enjoyed as a glimpse of a time past. Pictured at right are Mary Jane (left) and Anna Fahey; below is Frank Collins. (Right, courtesy Fahey family; below, courtesy Collins family.)

# AFTERWORD

As this text has shown, the Irish in Savannah have come a long way from being clustered in the poorest sections of the city and taking the lowliest jobs. This pride in their accomplishments is not new. Judge Walter G. Charlton, historian of the 75th anniversary of the Hibernians, commented that one always hears that the early Irish built the railroads, dug the canals, and, in general, did the dirty labor work. They did do this, they did it well, and it was necessary, honest work. Now, many of the Irish have jobs that require brains, not brawn, and they are doing those quite well too.

When the Irish came to Savannah, it was their kinfolk and friends from Ireland who welcomed them, Catholic and Protestant alike. However, it took some time for them to be accepted in "polite society." Today, however, the Irish in Savannah have gone from seeing signs that said, "No Irish or dogs allowed" to total acceptance. If you read the speeches given at the various Hibernian banquets over the years, you'd swear that each Irishman is given his own little Blarney Stone at birth to kiss at will. Not only do the Hibernians make good speeches, but they now have a Poet Laureate, Edward Brennan, who wrote the following about the Irish and Scots. It can be said today that not only the thistle and the shamrock, but all people in Savannah wish each other well.

"The Thistle and the Shamrock"

*Some say should never meet. The thistle's too prickly,*
*And the shamrock's just too sweet.*

*But they don't know old Savannah*
*Where peace and good-will dwell,*
*And the thistle and the shamrock clasp*
*And bid each other well.*

*Erin go Bragh! God Bless America! Y'all come visit us in Savannah!*

# BIBLIOGRAPHY

Fogarty, William L. *The Days We've Celebrated.* Savannah, GA: Printcraft Press, 1980.

Gleeson, David T. *The Irish in the South, 1815–1870.* University of North Carolina Press, 2001.

O'Hara, Arthur J. *The Story of a Century: Hibernian Society Savannah, GA. 1812–1912.* Savannah, GA: 1997.

Shoemaker, Edward Matthew. *Strangers and Citizens: The Irish Immigrant Community of Savannah, 1837–1861.* Ann Arbor, MI: UMI Dissertation Services/Pro Quest Co, 1990.

Smith, Gordon Burns. *The Story of the Second Century: 1912–2012: The Hibernian Society of Savannah, Savannah, GA.* Savannah, GA: 2013.

# Discover Thousands of Local History Books Featuring Millions of Vintage Images

Arcadia Publishing, the leading local history publisher in the United States, is committed to making history accessible and meaningful through publishing books that celebrate and preserve the heritage of America's people and places.

## Find more books like this at
## www.arcadiapublishing.com

Search for your hometown history, your old stomping grounds, and even your favorite sports team.

Consistent with our mission to preserve history on a local level, this book was printed in South Carolina on American-made paper and manufactured entirely in the United States. Products carrying the accredited Forest Stewardship Council (FSC) label are printed on 100 percent FSC-certified paper.

MADE IN THE USA